SUSIE'S
SENIOR DOGS

ERIN STANTON

GALLERY BOOKS

NEW YORK LONDON TORONTO SYDNEY NEW DELHI

G

Gallery Books
An Imprint of Simon & Schuster, Inc.
1230 Avenue of the Americas
New York, NY 10020

Photograph Credits
Photos on pp. 34, 35, 36, 37, 38, 39, and 41 courtesy of Sophie Gamand.
Photo on p. 42 courtesy of Chris Lee Photography.
Photos on pp. 56–57 courtesy of Judy Watts.
Photo on p. 58 courtesy of Marcello Fracassa.
Photo on p. 66 courtesy of the Gloucester-Mathews Humane Society.
Photo on p. 77 courtesy of Richard Phibbs.
All other photos courtesy of author or owners.

First Gallery Books hardcover edition October 2016

GALLERY BOOKS and colophon are registered
trademarks of Simon & Schuster, Inc.

For information about special discounts for bulk purchases,
please contact Simon & Schuster Special Sales at
1-866-506-1949 or business@simonandschuster.com.

The Simon & Schuster Speakers Bureau can bring authors to
your live event. For more information or to book an event, contact
the Simon & Schuster Speakers Bureau at 1-866-248-3049 or visit
our website at www.simonspeakers.com.

Interior design, illustrations, and surface design by Jane Archer
(janearcher.nyc)

Manufactured in the United States of America

10 9 8 7 6 5 4 3 2 1

Library of Congress Cataloging-in-Publication Data is available.

ISBN 978-1-5011-2247-7
ISBN 978-1-5011-2249-1 (ebook)

For Susie.

Thank you, God, for
entrusting me with
this little, furry,
life-changing gift.

Foreword

BRANDON STANTON, *Humans of New York*

One evening I was walking down a random street in Brooklyn when I saw a peculiar dog sitting on a stoop, soaking in some sun. I didn't know it at the time, but this animal would become my new best friend. I'd never seen such a neat-looking dog. I thought Susie was perfect in every way, down to the white tuft of hair on the top of her head that looked like a Mohawk. I remember thinking to myself, "If I ever get a dog, I want it to be exactly like that dog." I gave her several minutes of head scratches and continued on my way.

Several days later, I happened to be walking in the same area, so I stopped to see if Susie was outside again. I found her in the exact same spot. While I was petting her, Susie's owner came up to me. "I see that you love my dog," he told me. "I have to get rid of her. Would you like her?" The offer took me by surprise. I didn't know how to answer. I'd never had a dog before. I didn't have much money at the time, or even a secure living situation. I was sleeping on couches and changing apartments every few weeks. But it felt like destiny to me that I had been offered this dog. I felt like Susie and I were supposed to be together. So I pushed all reservations out of my mind and said, "I'll take her."

Getting Susie was the best decision I ever made. Even though she was twelve years old, she bonded to me so quickly. I learned that Susie wanted only two things: to eat and to be close to me. She taught me the magic of having a dog. Her only concern in life was my location. Every time I left the house, Susie would get upset. Every time I came home, she was overcome by excitement. We spent all our evenings together—just me and she relaxing on the couch. And that companionship meant so much, especially because I didn't know very many people in New York.

After I met Erin, we became a team, and Susie stole Erin's heart just as she'd stolen mine. Susie's Senior Dogs emerged from the friendship that developed between the two of them. Erin claims that it was Susie's idea to start Susie's Senior Dogs, but I'm pretty sure they came up with it together.

Introduction

ERIN STANTON

A side from growing up with my childhood dog, Pepper (an all-American mutt rescued at six months old by my parents when I was just an infant), I had little experience with animal rescue or adoption prior to creating Susie's Senior Dogs. After I left home for college and eventually moved to New York City, looking for a dog as a companion wasn't yet on my radar. I was consumed with figuring out things as a young adult living alone for the first time, and thoughts of bringing home a dog never entered my mind. It wasn't until I was twenty-seven that I became aware of the homeless animal crisis in the United States, and specifically, homeless senior animals.

My awareness came in the form of a little twelve-year-old, eight-pound Chihuahua mix named Susie. Susie belonged to Brandon, whom I began dating shortly after he (unconventionally) adopted her. During our dating relationship, I naturally took part of the responsibility in caring for her. Susie's mealtimes, pee breaks, and daily walks quickly became a part of my routine too. I took on the role of Susie's mom and I loved it! (Several years later, Brandon and I went on to adopt another senior, fifteen-year-old Simon; you'll hear more about his story later in this book.)

In caring for Susie, I immediately discovered that adopting an older dog was unusual. When people learned that Susie was brought home as a senior dog, the response was always the same: shock, surprise, and curiosity. This gave me an idea. Realizing that senior dogs were often overlooked, I began to search around on the Internet for homeless senior dogs in our area. Sure enough, I noticed there were many older dogs up for adoption at various shelters and rescues. And they were getting lost among the competion: cute puppies and younger dogs.

The first senior I located was Ashi. She was from Animal Haven shelter in New York City and she was having difficulty finding a home. Ashi, an eight-year-old Chihuahua/dachshund mix, needed a quiet household. She was considered a low-maintenance dog, but she preferred to find an adopter who could respect her space and wouldn't be offended if she didn't feel like snuggling. Ashi had

had a stressful past, and fast movements or suddenly reaching out to pick her up could startle her and sometimes cause her to nip in reaction. Dave, a good friend of mine, had never owned a dog before and had lower expectations of how a dog "should" be. He did have a realistic understanding about the importance of finding a dog who best matched his lifestyle, but beyond that, he was open to whoever his new best friend might be. So I figured Dave was Ashi's best chance at finding love.

Together, Dave and I went to visit Ashi at the shelter. When they first met, Dave was unfazed by Ashi's feisty personality and dismissive behavior. He submitted an application and was approved to adopt her! Of course, after he brought Ashi home, things weren't always easy; in fact, they were downright frustrating at times. It took several months for Ashi to become comfortable with Dave, but his laid-back personality was the right match for gaining her trust. And Ashi's low activity level was the perfect fit for Dave's hectic schedule. Although Ashi did snap at him on many occasions in the beginning, she's a different dog today than she was when Dave first brought her home. She has grown to completely trust her dad, she has become more tolerant of strangers, and her biting and snapping has ceased. And of course Dave is absolutely smitten with his doggy daughter and cannot imagine life without her. ☺

Although SSD did not yet formally exist, I consider the story of Ashi and Dave its first official success. Their relationship inspired me to continue promoting senior dogs and the incredible bond they are capable of forming if only someone will give them a chance.

Ashi's Story AS TOLD BY HER HUMAN, DAVE

When I brought Ashi home the first day, I thought that I had made a huge mistake. She had been at the animal shelter in Manhattan for over six months, and now I thought I knew all the reasons why. When I went to see her, she was so cautious and scared. She would only venture over slowly to snatch a treat from my hand before scuttling quickly back to the shelter worker. Though she didn't give me the time of day, she seemed fine with all the people working at the shelter, running up to them and licking them. So I thought, "Why not? I might as well give it a shot."

The people at the shelter were quick to let me know that I would need to be patient with her. They gave me tips: You have to put her leash on just so or she will try to bite you. You can pet her, but be careful of her hind legs, because she doesn't like that. I guess because she had been at the shelter so long, she had become a sort of unofficial mascot: the mean little frumpy dog that was blind in one eye and tried to bite you half the time, but was always so hungry that she would take a treat from anyone. How the shelter had managed to transfer her from the city animal control, I'll never know.

So here I was, an absurd sight: a fully grown man scared to death of a fat, half-blind ten-pound Chihuahua mutt with stubby legs, who would scarf any food from my hand but would snarl and bite whenever I tried to pet her. She perched herself on a mound of clothes in my bedroom and declared herself queen of the house. "Great," I thought. "I promised everyone I would take her. Now I'm going to be the villain when I march her back across town to the

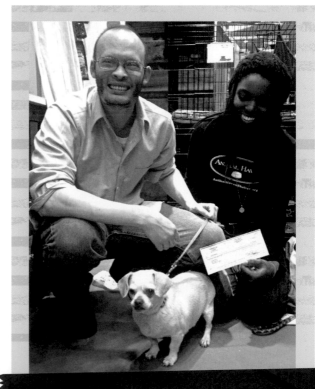

ASHI

shelter cage that was just supposed to be her canine halfway house."

However, I stuck it out. And something happened. Every month Ashi got more and more mellow. She would hover close to me for longer and longer when I gave her treats. Eventually I didn't even need to bribe her for affection, and she would trot up to me just to be petted. She started to lick me. After a while she didn't bite me anymore, and soon after that, she would whine to come up and join me on the bed (and sure, why not?).

9

I no longer think that I made a mistake when I let Ashi become part of my home. I saw that she wasn't really a mean dog. She just wasn't quite sure what to make of these huge humans who had hovered over her for her entire life, big menacing creatures who maybe hadn't always been so nice to her. She just needed a soft bed to lie in, a meal at night, and a friend to keep her warm just like any other dog (or person, for that matter). And she deserved it too, because she has a lot of love to give. So I'd say instead that I'm proud to have pretty much the best dog out there.

I saw that she wasn't really a MEAN dog. She just wasn't quite sure what to make of these HUGE HUMANS who had hovered over her for her entire life, big menacing creatures who maybe hadn't always been so nice to her.

Because their humans are friends, Susie and Ashi naturally spend a lot of time together too. On one particular afternoon during a doggy-hangout session, Susie and Ashi got to thinking . . .

Discussing our retirement. We're thinking of starting a senior dog and human matchmaking service.

On January 23, 2014, Susie's Senior Dogs was officially born. Susie was now around fourteen years old, and after two and a half years of caring for this wonderful old dog, I had accidentally discovered my greatest passion—helping homeless old dogs. Improving their lonely, vulnerable lives became my purpose.

The first thing I did was create a Facebook page to post the stories of senior dogs in search of a one-way ticket to a forever home. I knew that SSD would succeed only if we had an audience. I needed people to read about—and care about—the homeless seniors I found all over the United States. And most important, I needed the help of many people to spread the awareness for them. I worked on growing the SSD Facebook page (and eventually its Instagram, Twitter, and website) by consistently posting content relating to senior dogs and animal rescue. In doing this, I found that people are naturally attracted to older dogs, and the posts quickly caught attention on social media. Shining a spotlight on the unfortunate predicament of this special group of shelter dogs was eye-opening for many people—just as it had been for me.

The stories in this book are similar to the features found on the SSD social media pages—a collection of reader-contributed pieces that highlight the joys and the challenges, the humor and the heartbreak, and best of all, the incredible love that comes with adopting an older pet.

Mouse's Story AS TOLD BY HIS HUMANS, KATE & GINGER

Our darling Mouse is almost twenty now. He was ten when we pulled him from a rescue in Arkansas. In addition to having cataracts, he was emaciated and had a tapeworm, scabs, a limp, and a grand total of eight teeth. When we got him home, he snarfed down his first meal in snorting gulps, mewling all the while. I held him close and vowed to look after him for however long he had left. He was so sickly and pathetic, I didn't think it could be long. Never in a million years would I have guessed he was about to take me on a magical ten-year ride.

As soon as he was well enough, we took him in for cataract surgery. He regained sight in both eyes, but it was the change in his temperament that was truly breathtaking. He went from being Grumpapoto Mouse, inching his way around the house and snapping at the other dogs, to the King of Derring-Do. He even cornered a possum behind the garage. It was the dead of night: pitch-dark, mosquitoes everywhere, lots of barking and possumy wheezing. I put the flashlight in my mouth, bent down, eyes trained on the possum, grabbed Mouse, and backed us out. The possum hissed, mouth agape. My heart hammered away, but Mouse strutted around the house, letting every-one know he had vanquished that there possum.

For months, every chance he got, he was out that back door like the proverbial bullet. Just when I thought his memory of Possumgate was fading, I heard an earsplitting yelp. I galumphed through the herb garden to find Mouse nose to nose with a blur of fur, gnashing teeth, and flashing claws. It took me a whole snarling, barking, scrabbling minute to get him out. Blood dripped from his ear. He needed a stitch, but was full of beans. No possum this time–turned out he'd gone toe-to-toe with a cat in the process of giving birth.

As his health improved, Mouse's tiger self bloomed. He brought us a squirrel tail one day; a foot, another. (We never did find the body.) He squared off with the raccoons and salivated by the bathroom door when we rescued some feral kittens. He fell off the deck and broke his tail; had bone spurs shaved from the head of his femur, then spent several months going to doggy rehab, where the rehabilitation specialists made him walk on an underwater treadmill. Sing along with me: "Mouse no wanna go to rehab, he say no, no, no." So much for thinking we'd have only a few sleepy months with him!

Turns out, my darling Mouse is a resilient little love monkey, and until about a year ago, when he was an estimated nineteen years old, he eagerly cavorted with the other five dogs in the house, whipping my still-warm sock about his head when I came home. As he approaches

twenty, he's frail but tenacious. Though he can hardly see or hear, has lost his lovely undercoat to a thyroid condition, and has a hunched back because of Horner's syndrome, he still revels in the sunshine, gobbles down his grub morning and night, and snorts contentedly as he sleeps on my chest.

He's not the rascal he once was, but that's been one of Mouseketeer's many gifts: to show me what it is to love unconditionally. As the embers of his huge personality dim and fade and the fearless possum-chasing Mouse of yore is replaced by this little old man, tottering about on unsteady pins, I find I still adore him.

Some people would say his time is up. I see it all the time at the shelter where I volunteer: As soon as older dogs start to lose their marbles, they're put to sleep. But we have a pact with our Mouse: No one's going to tell him it's over until he says it's over.

It's been almost ten years since I first held Mouse in my arms and told him I'd do my best for him, and he's still here, his much-kissed snout resting on my knee, heavy sighs urging me to finish up so we can go to the beach, somewhere he can sniff after the waddling gulls and remember what it was to be a young Turk of ten, or even a whippersnapper of eighteen, and race after them.

Mouse's days are jam-packed with love, smells that change with the tides, the roar of the surf, and that never-ending beach. He can't see any of it–not the puffins or cormorants or pigeon guillemots; not the whales out on the horizon or the pelicans dipping into the surf; not the sky reaching down to the roiling blue at the end of the day, exploding in oranges and reds before it slips into bed; or the loving faces bending over him each night to kiss him to sleep–but I can tell you for a fact, Mouse loves his life and he lives each day, as he has since the first day we met, as if it were his last. I tell him, "I will love you, Mouse, all the days of my life." And I mean it. Even when he's gone, he'll be here in my heart, where he belongs.

CONNECT: **f** / TREASUREMOUSE

POSTSCRIPT:

My tiger-hearted Mouse was twelve days shy of his twentieth birthday when he sighed his last and went on his way. He died at home, curled in one of his favorite fluffy beds. He lay in state for a full twenty-four hours so the entire pack could say good-bye. Each night, before my head hits the pillow, I close my eyes, conjure Mouse up, and offer him a wee, imaginary possum or an invisible feral kitty and a handful of delectable, etheric puppy num-nums in hopes he'll chase them into my dreams, where we can play some more.

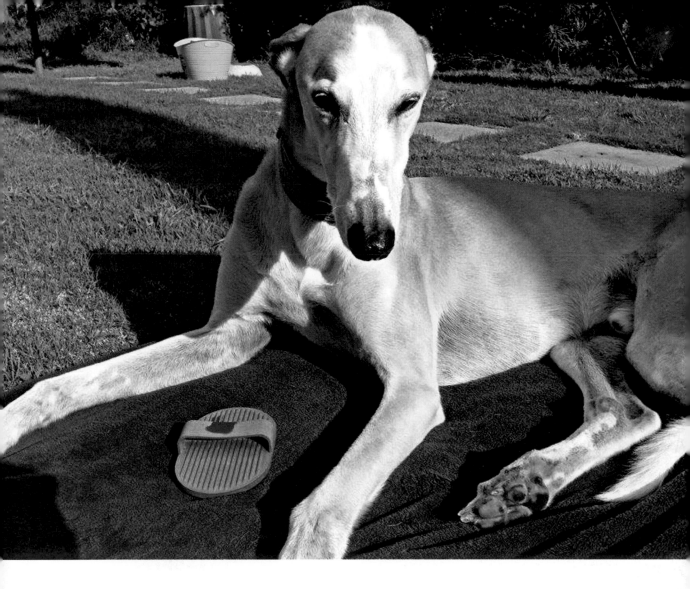

Rex's Story AS TOLD BY HIS HUMAN, ANGIE

For most of my life I've lived with my family in rented houses, and tenancy rules prevented us from having a dog. I still remember the day I came home from school and Mum shared the good news with me and my sister: She had asked our landlady if we could get a dog, and the landlady had agreed. We were all so excited, dancing around the kitchen! We were already hooked on the idea of a retired racing greyhound. We knew of the plight they faced when they retired from racing. Many racing greyhounds are essentially a commodity to their trainers, and the saddest part of this is that most greyhounds do not make it past the age of three in their racing careers. If more people knew the bleak future that greyhounds face after racing, maybe more greyhounds could experience the love and comfort of an adopted home.

Rex is Rex and he, like all senior dogs, has so much LOVE for you that it makes up for lost time.

There is a special facility in my area that teaches greyhounds all about home life after they've retired. They learn things like where to go to the toilet and how to walk up and down stairs, and they become socialized with people and other animals. When we drove into the facility's adoption center, there were pens lined up along the driveway, each containing a lean greyhound. They stood tall, some barking, others wagging their tails and jumping up onto the door of their pens. They poked their long, skinny noses through the grid of the fence, hoping to get a good sniff of the new humans they were meeting. Touching a greyhound for the first time is a surprisingly bizarre experience. Their backs are only slightly wider than the span of your

hand, and it is difficult to ignore the hard ridge of their spines. They have a tendency to park next to you, settle their head on you, and lean, letting their whole weight sway onto you. Now, whenever I pat another large breed dog, they feel too wide, pudgy–their skin too thick. You feel disconnected by an excess of flesh.

The pens were divided between those holding female dogs and those with male dogs. Rex was in the female section because of his very submissive nature, which we thought was sweet. Each dog's cage had a little spiel written about him or her. I still remember Rex's saying that he thinks he's a "legend in his own lunch box" (Australian slang meaning a person who thinks he's just great!). It's true–when someone knocks on our front door, he runs to the door, not to bark or defend the property, but to get a pat.

Taking him into the yard, we realized that former racing greyhounds aren't like normal dogs. They don't come when they're called, they don't fetch, and they can't seem to sit (they just lie down on their sides). These are just some of the odd things that make retired racing greyhounds so gorgeous. I can recall the way we all looked at each other and knew that we were all thinking the same thing: We wanted Rex.

When we first arrived home, he wouldn't get out of the car. He just sat in there with the doors open for about two hours, then in his own time wandered in through the back door. The first night he was very restless. He walked around the house all night, not really sure what to do with himself. He also had some housebreaking issues. Because he had always been kept in a pen, he used to go right outside the back door. He didn't realize that he had the whole yard to explore. But he was quick to learn where he was meant to go to the toilet, what time his dinner was, and

how our car sounds when we're driving up the driveway.

Rex is almost completely silent. He plods around the house so calmly. I know he's coming only when I hear the click-clack of his nails on the floor. He also has little awareness of his surroundings. Quite often he'll stand in a room completely still, staring into space, not responding to anyone at all. He whines when he wants attention, but he almost never barks. He leans on things–walls, doors, furniture, people. Greyhounds love leaning on people when they're being patted. He does a sort of parallel park next to you and then just leans his whole body on you. It sort of reminds me of Michael Jackson in the "Smooth Criminal" video.

As he gets older, he sleeps more and prefers to be inside if there's no sun for him to lie in. We like to think of Rex as getting "promoted" in our household. He started off sleeping in the lounge room at night, and being outside with a shed for shelter during the day when we are out. He then went through a stage of lying on the couch all day and ignoring you when you called him to come outside, so he got promoted to being a full-time inside dog (unless, of course, there's sun for him to bask in). A few years ago he was attacked by another dog, and after that he was promoted to sleeping in the bedrooms. He now has full access to all the house with a choice of several mats for him to sleep on. I joke that when he's very old, I'll build some stairs to the couch so that he can just walk up them without jumping.

I used to be worried that because he was older, there wouldn't be enough time to spend with him, that it would be easier to adopt a puppy because then you don't lose them so soon. I've forgotten all about that now. Rex is Rex and he, like all senior dogs, has so much love for you that it makes up for lost time. ♥

A FULL HOUSE, WITH ROOM FOR MORE

One of our earliest success stories from the site was Phyllis, a senior dog who was posted on SSD less than a month after the site had been created. Phyllis's adopter, Steve, is an amazing pet dad. He lives in Colorado with his nine dogs, Bikini the pig, a rabbit, chickens, and some ducks, all rescued. When he adopted Phyllis, Steve's Instagram account, @wolfgang2242, had only a few hundred followers. But his amazing rescue household quickly caught the attention of many people. To date, he's grown to 550,000 followers and counting! And the number one burning question his fans always ask is "How do you keep your house so clean?" 😉

Phyllis & Company AS TOLD BY THEIR HUMAN, STEVE

I was pretty new to Instagram, but somehow I stumbled onto the Susie's Senior Dogs page. I already had seven dogs by this point, so I was not looking to add another! But one day I saw the post for Phyllis, who was in a small remote shelter in eastern Colorado a few hours from where I live. She was blind, had lost most of her hair, and was so intent on getting out of the cage that she had rubbed deep sores on her snout. I don't know that I've seen a more unattractive dog. I couldn't get her picture out of my head.

I called the shelter and made arrangements to come visit Phyllis the following weekend. I brought two of my dogs on the trip to meet

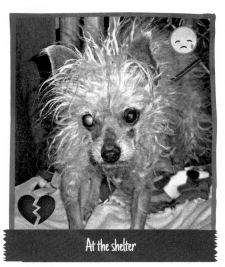

At the shelter

Phyllis just to make sure there wouldn't be any problems. I remember walking into the shelter and seeing the representative holding her right inside the front door. This tiny, frail blind dog somehow managed to pull off an aura of quiet self-confidence. I was told she was found on the highway, close to a farm. Someone had probably dumped her there. The vet said he could tell by her condition that she had produced several litters of puppies and that she was probably used for breeding. I couldn't wait to get her out of the shelter and spoil her with the life she deserved to have. She fell asleep with her head on my leg on the drive home. I think she knew life was about to get much better.

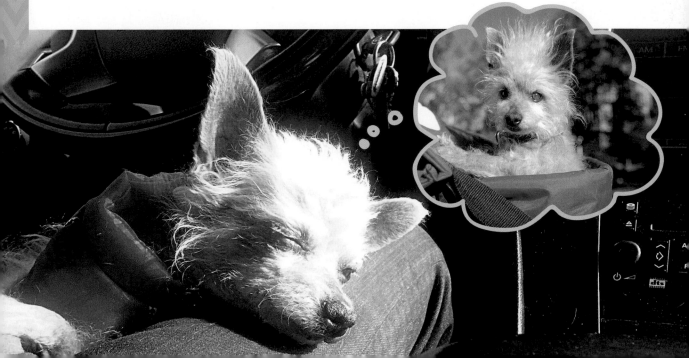

Phyllis came home to what must have seemed like a small zoo: a mishmash of dogs, chickens, ducks, a rabbit, and an eighty-five-pound prima donna pig named Bikini. Of course this is a lot of animals to have in one household. But I have been blessed with the means to take care of them. I think every animal is important, and I know in my heart this is what I am meant to do with my life.

Bikini is the self-appointed queen of the household, a title that she believes gives her unequivocal rights to everyone's food. She loves us, but she loves her food more.

BIKINI THE PIG

I adopted fourteen-year-old **Eeyore** when Wolfgang, the namesake of my Instagram account, died a couple of years ago. Eeyore is the most easygoing Chihuahua you will ever meet. He loves all toys, all people, and all dogs, in that order.

Loretta is a twelve-year-old terrier mix, a shelter rescue, and just the opposite of Madeline. She tries to let me know every waking moment how much she loves me and how she needs to be with me everywhere I go.

LORETTA

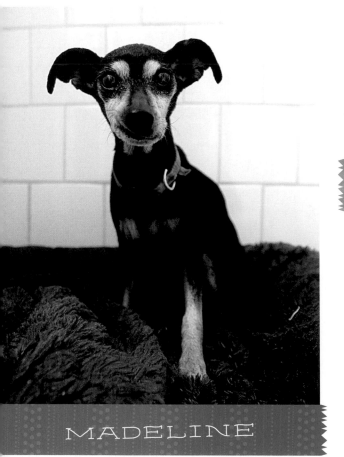

MADELINE

Madeline is a sixteen-year-old black-and-tan miniature pinscher who generally prefers to be alone. She came to me when her owner moved and couldn't take her along. I've learned she is like one of those people who rarely say, "I love you"–but you know they do anyway.

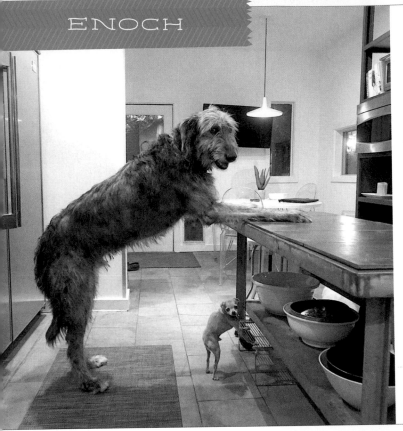

wolfgang2242 FOLLOWING

39.9k likes

wolfgang2242 One of these dogs has a clearly larger than life presence, whose mere physicality, elevated by an extreme amount of self confidence, intimidates any would be intruders and provides a sense of security for the entire household. The other one is an Irish Wolfhound.
#measuringup
Enoch and Englebert

view all 2,968 comments

iremgirmen @cchao8

vbrittanyv @minichikhloe pic and caption 🐾

cchao8 @iremgirmen oh dang haha I love this

melissacrozierr @alxndav this will be my life lol

rika_ryan @jessicacantrell_ !!!!

Add a comment... ○ ○ ○

Enoch is an Irish wolfhound. At five years old, he is by far the baby of the group. He is sweet, gorgeous, and clumsy, and seems like the oversize, protective brother of this pack of much smaller dogs.

Englebert is only eight, but he shares Phyllis's heartbreaking past. His previous owners kept this four-pound Chihuahua as an outside dog in the Colorado winter. By the time he was taken away from those owners, both ears had frostbite and he had suffered some neurological damage. He is a true survivor and the brightest light in this house.

ENGLEBERT

Hercules provides the standard on how to age well. He is an eighteen-year-old miniature pinscher who still goes on walks with the pack.

Finally, Edna is my newest rescue. She's a twelve-year-old bichon mix whose owners could no longer care for her. Her picture should be beside the word *grateful* in the dictionary. She's short, stout, and full of adventure. I like to say she's rugged like Sean Connery, with Dolly Parton hair.

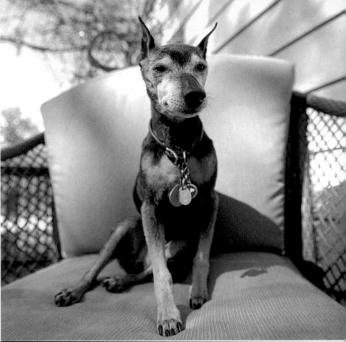

HERCULES

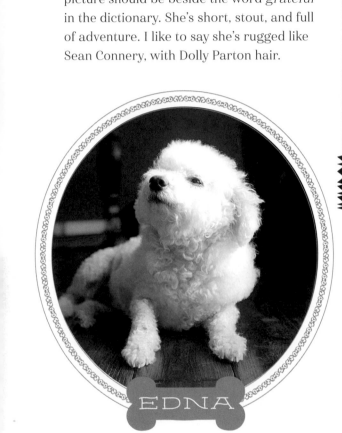

EDNA

There are a few basic things that really help me to manage multiple dogs (and pigs and birds and . . .) while balancing a career and a social life. I have a doggy day care that I can use during the week or for overnight boarding on short notice. A doggy door gives them access to the yard when I'm gone for more than an hour or two, and it is a lifesaver. A "safe room"–a bathroom or laundry room where I can leave the smaller, more fragile dogs–is also a big help.

When I go out for the evening, I don't have to worry about anything happening to them. It has a few of their favorite beds, a water bowl, and a tile floor in case there are any accidents. Having a reliable friend or house-sitting service to fill in for me when I need to be out of town is also very important.

I'm lucky in that I also have a roommate and a housekeeper who are a tremendous help with the dogs, but the bottom line is that people will find time for the stuff that makes them happy. I can't think of too many things that give me more joy and peace and meaning than senior dog adoption. Most of these dogs are either unwanted or abandoned, and they are usually frightened and withdrawn. When I see them learn to love and trust and play again, it feels like all the other stresses of my day are unimportant. Any minor extra effort it takes to fit them into a schedule is quickly forgotten the moment they make you laugh and feel loved, comforted, and needed.

This misfit group makes up Phyllis's new, perfect family. Out of all the dogs available for adoption, I've been so grateful that God always seemed to direct me to the ideal dog. However, after the last few extraordinary dog adoptions, I realized it wasn't just divine intervention. Every senior dog out there waiting to be adopted has something special to offer.

CONNECT: 📷 @WOLFGANG2242

Susie Tip!

Many animal shelters run on limited resources. Some shelters even rely solely on volunteers, with no paid staff. Often, small and rural facilities are surviving on the kindness and support of their communities. If you're seeking ways to help the homeless animals in your area, we encourage you to connect with your local shelter. There are many ways to help beyond donating money. Needed services such as daily cleaning and washing of kennels, washing and folding laundry, cleaning toys and food bowls, walking the dogs and spending time with them outside of their kennels, answering phone messages and emails—these chores all require helping hands. So consider your talents and how they might best be used to help. The shelter animals will thank you for it!

Dallas is an eight-year-old pug/Chihuahua mix who was at the Logan County Humane Society in Sterling, Colorado, the same shelter Phyllis was adopted from. Dallas had a very hard time "showing well" in the shelter. He was fearful and reserved, and when people passed by his kennel he would hide or snap if they got too close. But once outside the shelter, Dallas was a completely different dog. Socialization, enrichment, and daily walks are very important for shelter pups, especially for long-term residents. (And good news! Dallas has been adopted!)

ADOPTED!

Why I
Volunteer

CAROL

...A MIXED BREED IS AS HIGHLY ADOPTABLE AS A purebred. THEY SIMPLY NEED THE CHANCE.

I work at the Animal Care Centers (ACC) of New York City as a volunteer. I am a Level 2 Dog Companion, which at ACC means that I have volunteered enough hours and am experienced enough to work with dogs who have just entered the facility and have not yet been behavior evaluated, or have been evaluated and deemed not appropriate for adoption. I also photograph, video, and write biographies for those dogs with whom I interact for ACC's adoption site.

Like many city-run shelters, ours is open admission—every stray, every surrender, every injured animal must be taken in. The volume is high, and every animal needs attention from an already overwhelmed staff.

Private shelters are selective about which animals they take, reserving the right to accept only those dogs or cats they think they can place. The city shelter, by contrast, must accept all animals either brought in by its own staff or surrendered by owners. The ACC in New York City works with a number of rescue groups who are approved to "pull" from the shelter for their own fosters or adopters.

I work with all of the dogs, but pay special attention to those confused about being surrendered by their families and uncomfortable in a shelter environment. Many dogs, even those that come in as strays, are very fearful and stressed in a noisy, busy, hectic environment, probably unlike anything they have known. And many dogs, even those that lived in a family, are not socialized outside their immediate family, so being in a place surrounded by strangers, other dogs, and constant activity understandably stresses them. In addition to making them feel more comfortable for health reasons (stress compromises the immune system), I aim to get them comfortable enough to become adoptable.

Before I started volunteering at a city shelter, I had never stepped foot in one. I just didn't think

Jemma looked nervous in her shelter cage, which can discourage adopters.

JEMMA

Would you believe this is the same dog? Jemma loves a game of snowball fetch.

about it. But city shelters are more proactively reaching out to the public to raise awareness of their services and encourage adoptions. So many people think that animals in a city shelter are "bad," but the truth is that most of the animals were originally someone's pet and are there through no fault of their own. The families moved, or could no longer afford care, or developed an allergy—any number of things can result in a dog or a cat landing in a shelter. Some people are reluctant to adopt a shelter dog because they think a purebred animal will be in better health or will have a better background. This couldn't be further from the truth—a mixed-breed animal is as adoptable as a purebred. They simply need the chance.

How the shelter dogs got there doesn't matter. What does is that they all need and deserve good homes. They are so loving, so grateful for attention, so happy to have a new human friend. As bad a day as I might be having, nothing compares to the day the dogs are having, and if I can alleviate their stress for thirty minutes by exercising them, snuggling with them, and letting them know they have a friend, it completes me.

We always say that rescue dogs know who their hero is and will love that person unconditionally for the rest of their lives. This is so true; I see it all the time in those who are lucky enough to find homes. The reality is that ALL shelter dogs and cats need homes. Adopting an animal from an overcrowded shelter will be the best decision you'll ever make, and when you look into the eyes of the animal you adopted and see the love reflected back at you, you'll be reminded of that every day.

"...when you look into the eyes of the animal you adopted and

SEE THE LOVE

reflected back at you..."

susie tip!

Some people call me a mixed-breed, but I just call myself Susie. I'm a dog who loves people, food, and naps. I'm indifferent toward other dogs and cats. I am a seasoned traveler, I enjoy sunbathing, and although I can be a bit lazy at times, I like long walks with my humans, without a care of who or what is passing me by on the sidewalk. My humans say that my temperament is fantastic and just as easygoing as one might seek a purebred dog for. Shelters are filled with dogs with all sorts of personality types and temperaments. Many shelter dogs are surrendered by their owners for reasons related to the human, not the dog, and they come with known histories and "report cards." All dogs deserve a fresh start when seeking a home for the second (or third or more) time, but it's possible to adopt a dog with fewer unknowns than you might think. And, hey, it just might get you a cool Mohawk too!

Rocky's Story
AS TOLD BY HIS HUMAN, M.K.

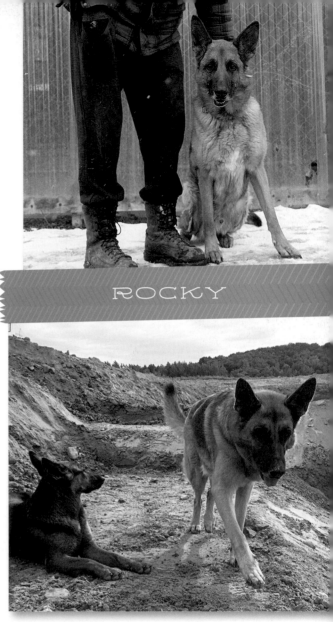

ROCKY

I always thought that getting a puppy was the best way to avoid adopting someone else's messed-up dog. When we found senior Rocky, we had three dogs: our original Chihuahua, Bella; our rescue shepherd, Loma; and our rescue Chihuahua, Comet. My husband, John, had expressed an interest in getting a male shepherd, so when we saw a photo of Rocky at a Big Sky Ranch Animal Sanctuary in Canada, John brought his phone to me, held out the photo, and said, "Look, I found the perfect friend for Loma." He had spoken at length with the owner of Big Sky Ranch and it sounded like a good fit. So John drove to Kemptville, Ontario, five hours away.

They arrived home at midnight. I left the Chihuahuas in the house and took Loma outside with a training leash. John had Rocky on a leash as well. They got out of the car and we just silently walked down our long driveway together while the two dogs sniffed at the air to learn about each other. As we walked back up the driveway we walked closer together until the dogs were side by side. Then we brought Rocky into the house and set the two dogs up on mats together.

The first few days were hectic. There was a lot of barking. Our smallest Chihuahua did not like the way Rocky lifted his entire bum off the ground when he sniffed him. Our chubby Chihuahua hid in her crate for about two days. Loma and Rocky wandered around the property together. Loma seemed to become more adventurous, almost like she was showing off by taking Rocky for tours of the land. Rocky stayed close by—we doubt he had been allowed off leash on thirty acres before. We watched Rocky carefully to make sure he wasn't going to go after the cat or the chickens. He was curious but respectful. Rocky was a little too interested in the food on the kitchen counter during meal prep, but he is very smart and responds to correction well. A simple no and he backed off.

Rocky seemed anxious the first couple of weeks, but now he lounges around and gets up only if he wants to follow someone around the property. Rocky follows us wherever we go and

then patiently sits and waits while we are working. When John leaves for work, Rocky waits for him at the front door. For hours.

We also discovered that Rocky basically speaks English. He is a smart, mature old boy and already understands a ton of commands. When you get a young dog, you spend a lot of time teaching him. Older dogs already understand so much. It's amazing how many words Rocky knows! He is also very amusing. He's a vocal dog, so we hear lots of grunts and moans as he expresses his opinions.

We noticed that the dynamics of our original pack have changed. Loma, who is only two years old, actually calmed down. She stopped being such a needy spaz! She became more confident and less fearful of people. It was almost like Rocky's maturity was rubbing off on her. She plays less with Bella, but now Bella plays with Comet. Loma isn't asking to come in the house all the time anymore; she enjoys exploring the property now that she isn't doing it alone.

That made life easier on us. Because Rocky is a mature, relaxed dog, he gives off a chill vibe that the pack feeds on. We've benefited from having a smart, older dog around to guide the youth. We are amused by his silly, curious character. And ironically, we don't have to lock the front door because everyone is terrified of him when they come up the driveway!

When you get a young dog, you spend a lot of time teaching him. Older dogs already understand so much.

It's amazing how many words Rocky knows!

MAKING PITS PICTURE-PERFECT

Sophie Gamand is a well-known photographer who has made shelter dogs her muse. Sophie is constantly advocating for shelter animals and coming up with creative projects to highlight how special shelter animals are. My favorite of Sophie's projects is *Flower Power: Pit Bulls of the Revolution*, a series in which she photographs pit bulls dressed in handmade flower crowns to give them a softer image, one that is more true to their temperament. Through her unique photo shoots, Sophie is breaking down stereotypes and giving shelter dogs the spotlight they deserve.

Sophie Gamand, PHOTOGRAPHER

started photographing rescue dogs in 2010. At first I had a practical approach: I would take their portraits to help them get adopted. But soon I felt a much deeper connection to the dogs, and to my mission. Many of the dogs I photograph come from worlds of terrible neglect and unspeakable abuse. When I meet them for their portraits, these dogs are in the process of transitioning into a world of caring. They are regaining their dignity, and that is something I want my portraits to reveal. These images carry promises too, for the dogs and the adopters, of a better life and unconditional love at last.

When I started offering my services to shelters, I found many closed doors. So I spent time educating rescue groups and shelters on the importance of good images. A clear, attractive photo can help an animal be adopted much more quickly. But things have improved, and now I notice a difference. There are more photographers offering their services, so that's a great evolution. Now shelters tell me that when the photos of their dogs are really good, they are shared much more on social media than the photos they might take themselves. It leads to more exposure for the dogs and for the shelters.

I created the Flower Power project to get better acquainted with pit bulls in general. I would meet lots of them in shelters, and would tend to tense up around the most energetic ones. I had prejudices (in part because I was attacked by a large herding dog as a teenager, which left me uneasy around some dogs), but was determined to overcome them. Then I discovered the reality of the pit bull crisis in the United States: Between 800,000 and 1 million pit bull-type dogs are euthanized every year. That number stabbed me in the heart, and there was no turning back.

With this series I wanted to help shelter dogs get adopted but also challenge our perception of

Many of the dogs I photograph come from worlds
of terrible neglect and unspeakable abuse. When
I meet them for their portraits, these dogs are in the
process of transitioning into a world of caring.
They are regaining their **dignity**, and that
is something I want my portraits to reveal.

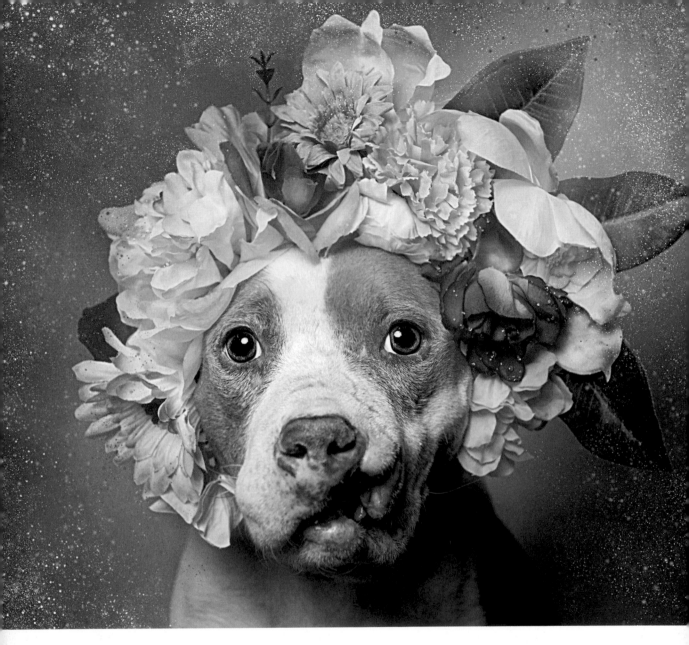

pit bulls in general. I believe that if we stop being afraid and listening to the myths surrounding them, we can change their fate. I always tell people: It's fine if you don't like pit bulls. Not everyone needs to like them. And not everyone should adopt a pit bull. But what is not okay is the systematic production and destruction of pit bulls in such staggering numbers. It's a matter of the kind of humane society we want to be and how we want to treat other living creatures around us.

I have created over 250 *Flower Power* portraits since I started this project, and it has gained international attention. Most of the dogs have been adopted, sometimes thanks to the photo itself. Under the hashtag #PitBullFlowerPower, the series has become a movement on social media. I suppose the success of the project partially answers one of the interrogations I had, whether or not art was a tool powerful enough it could change the fate of pit bulls.

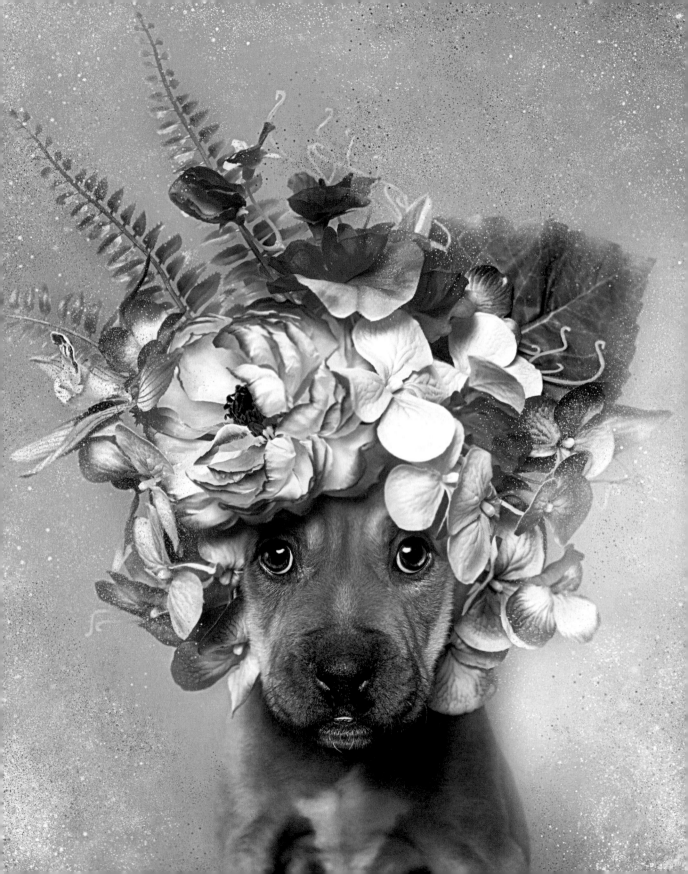

Some people are scared of aging, but for me, life has only gotten more exciting as I get older. Believe or not, I got famous at the age of eighty! (That's my age in human years, of course. It sounds more impressive, right?) I've even been featured in four doggy books. Sophie, the photographer whom you just read about, made a book called *Wet Dog* (a book about wet dogs, obviously), and I'm in it! Sophie came to my house, made me pose nude in the bathtub, and then photographed me soaking wet. Buck naked.

At first I was a little unsure about exposing myself this way. But when I saw my spread in Sophie's published book, well, I sure looked fantastic! So don't be scared of old age. Great things do still happen.

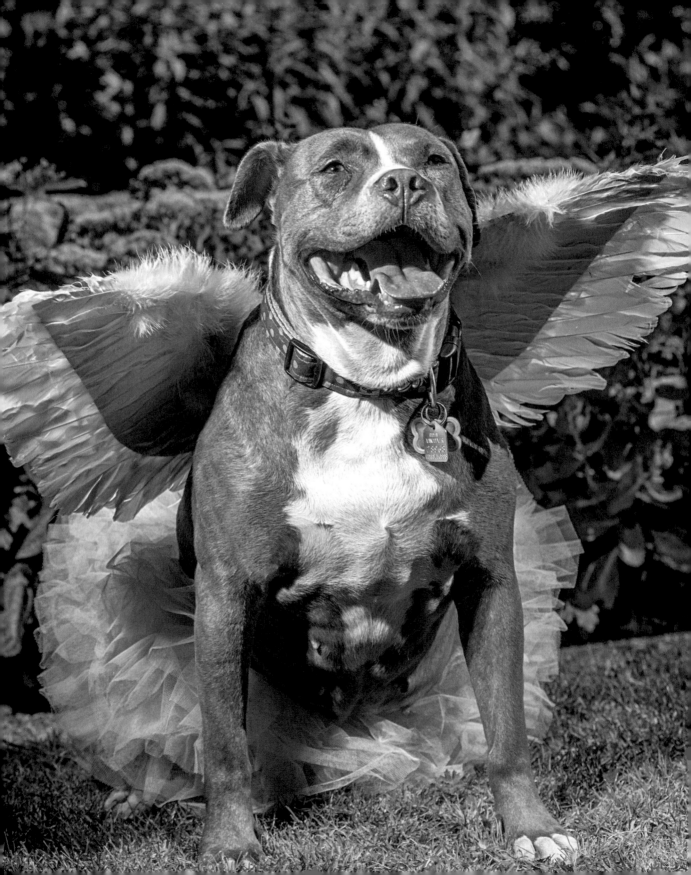

Lexy's Story As Told by Her Human, Jenny

I first met Lexy in February 2014 at our local animal shelter when she was eight years old; she had been there for many months waiting for someone to notice her. My heart was grieving after losing my previous senior rescue, Pete, to a deadly immune disease. Pete's loss took a strong emotional toll on me, but the love he and I shared allowed me to see through my grief. I knew I had to honor his memory and my new-found strength by helping another senior dog in need. And to Lexy I owe a great debt—she picked up right where Pete left off and has taught me much about forgiveness and acceptance.

Lexy was a rescue from a backyard breeder, where she had spent her entire life in a cage. As a result she was skinny and unkempt, her belly touched the ground, and she was fearful of open spaces, of fresh air and parks. When we first adopted her she hid under tables and hugged the walls when she walked through the flat. She loved people, and because of that, her story was even sadder. To top it off, she was a senior dog and a pit bull. In the eyes of "traditional" adopters, Lexy was unadoptable. But I didn't see any of these things. I simply saw a dog in need of a home.

I chose Lexy because she was the underdog, because she was marginalized. I chose Lexy in the hopes of redeeming humanity in her eyes for what they had done to her. I didn't choose a pit bull—a pit bull chose me.

Lexy is many things to many people. She has been described by those who've met her as a snuggler, a lover, and a lapdog—and by those who don't know her as a monster and a killer. It's not Lexy herself, but rather the stereotype of pit bulls they're describing. Our neighbor actually said that her Chihuahua was "born to sit on the laps of royalty," whereas Lexy was "born to tear other dogs to shreds." I prefer to think of Lexy as my best friend. But to define her as a collection of adjectives is to miss the incredible opportunity to really know her, to really know the heart of a pit bull. Sadly, this is exactly what most people do. The words *pit bull*, in just seven letters, carry a tremendous burden of redemption almost everywhere they appear. Pit bull parents are forced to defend the mere existence of their dogs, and dogs and people are judged more critically than others simply on sight.

In a significant portion of the United States and the world, pit bulls are not welcome and their individual characteristics and personalities do not matter. The misinformation about these beautiful dogs is rampant, and those who spout anti-pit bull rhetoric purposefully capitalize on the public's fear created by the media's use of graphic photos of

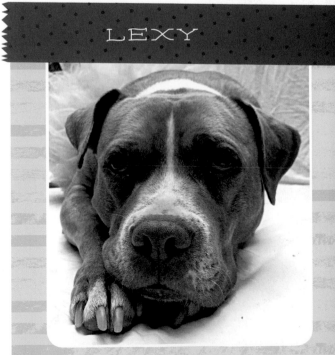

LEXY

tragedies and stories of dogs forced to fight for the entertainment of humans. The response is harsh anti-pit bull laws, referred to as breed-specific legislation (BSL). It is important to recognize that *pit bull* is not a breed; rather, it is a collection of physical traits that create an image of a pit bull. Each dog, regardless of breed or physical traits, has its own personality and must be considered on its own merit. Dogs are born inherently good; they do not possess the capacity to hold grudges, to be vindictive or vengeful.

Lexy is everything the media portrays her not to be. She is a silly, happy, outgoing girl who loves to cuddle with humans. She does not let her past interfere with all the love she desperately wants to give. She snuggles in close and licks your face. She wrinkles her nose when you say *bath* and waggles her tail with enthusiasm when she hears her name. She desperately wants to meet the Chihuahua who lives next door, but when he barks, she gets scared and runs away.

She enjoys swimming in the ocean and sunbathing in the grass. She wears tutus and tiaras. She sleeps under the covers every night and snuggles in to share my pillow. She never lets age get in the way and outplays all the puppies at daycare.

Lexy is first and foremost simply a dog. Yes, she is a pit bull-type dog, but that doesn't define her. She is a collection of her hopes and dreams and compassion. She is simply a dog who wants to love and be loved.

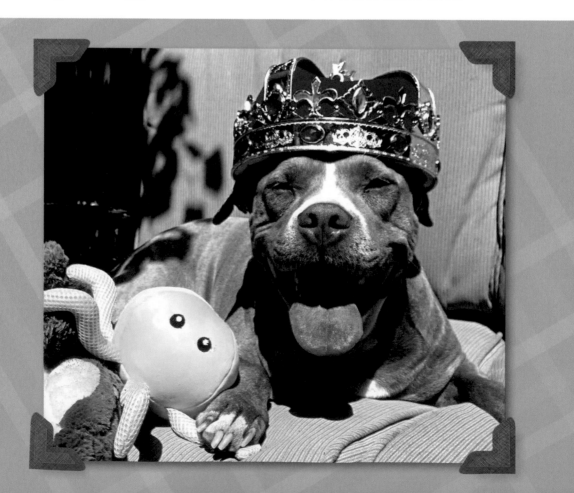

Susie Says:

I love to travel with my parents! I let them think I care about sightseeing, but really I'm just so happy to be hanging out with Mom and Dad. I have to admit, though, that the time I went to Hollywood was pretty neat. I felt like a real star! But I was excited to go back home, because we all know I'm a true New Yorker! 🐾

Old Dog, New Adventures

At the age of twelve, Susie took her first cross-country vacation with us all the way to San Francisco! Even at her older age we've still been able to experience many "firsts" together. How Susie spent her days before joining us is mostly a mystery. But that doesn't matter, because our unique experiences together now are just as thrilling as they would have been had we adopted her when she was much younger. Susie is an amazing little traveler, unfazed by car, air, or train travel. She has dipped her paws in the Atlantic and Pacific oceans, she has traveled to more than seventeen states, and she's even crossed the border into Canada. So long as Susie is near us, she is happy! ❤️

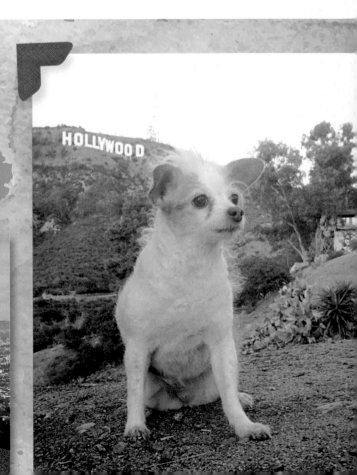

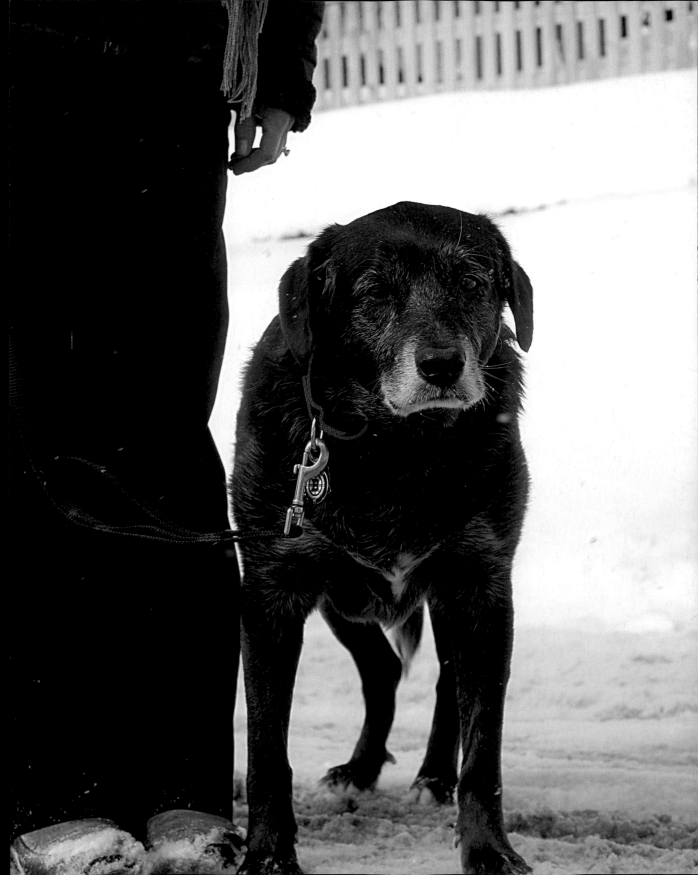

Alexandria's Story As Told by Her Human, Christine

After my husband, Jim, and I were married, we purchased a golden retriever puppy. Jim says that when he was growing up, that was how you got a "good" dog. We were aware of animal shelters but hadn't thought about adopting a shelter dog. We didn't know anyone who had adopted a dog. When we had our golden, Reilly, she came to work with me and I walked her in the park across the street every day. That's how I met so many great dogs who had been adopted. It was the norm in Cambridge; many people adopted, and not just puppies. It's interesting thinking about it now–the dog we purchased from a breeder led us to our first adoption.

After we lost Reilly we took some time to grieve, but once in a while we talked about what we would look for in our next dog. I really wanted to give a homeless dog a home and Jim was neutral about adopting a dog. He missed having a dog, but also enjoyed the freedom of being able to come and go as we pleased.

A year or so later, I started researching animal adoption and connecting with animal shelters and rescues on social media to get a feel for the whole process. My friend Joanna, knowing we wanted to adopt a senior dog, recommended the SSD Facebook page to me. I was struck by the number of times certain senior dogs were posted because they were having a hard time getting adopted. When SSD talked about how hard it is and how long it takes for senior dogs to be adopted–that was eye-opening for me. I became even more attuned to looking for older dogs through the various other rescues I followed.

There is a dignity to older dogs, and I wanted to honor that. And at the same time, we realized that we weren't prepared to raise another puppy now that we were at a different stage in our lives. Realizing that there were so many lifestyle benefits to adopting an older dog, we agreed that I could start looking. I would send Jim pictures of dogs from time to time, but he wasn't open to any of them until I sent him Ali's post.

I was following SSD, but it was Joanna (my rescue mentor, one of the people who showed me how good it could be) who sent me Ali's post on SSD with a note reading,

"How about this cute girl?"

Ali was with a local rescue I had never heard of and was being fostered about an hour away. There was something about her face and story that touched me. The rescue group had named her Alexandria, which is the name of a great friend of ours. I just had a gut feeling that she could be our dog.

We decided to meet Ali, which Jim thought was strange: "So we're going to Petco to meet this stranger who has a dog we might take

home?" I said, "Yes. Let's go meet her and see if there's any chemistry. It's like speed dating for dogs." Of course we get there to meet them and there is a puppy playgroup with a golden retriever puppy in it. I almost lost Jim. While he was talking with Ali's foster father and side-eyeing the puppy, I took Ali and we just hung out for a while, walking around the store and talking to people. She has this really sweet habit of poking people in the leg with her nose, as if to check in. I was sold. We left Petco with a dog in the car for the first time in years.

Jim went along with this but was still fairly neutral about Ali and having a dog in general . . . until she was injured. Not long after we adopted her, she pulled a muscle jumping up on the bed and had to sleep on the first floor of our house for a couple of weeks while it healed. Jim decided to sleep in the living room with her so she wouldn't be alone. He said it was then that they bonded. She was so vulnerable and so sweet that he couldn't help but want to care for her and love her.

Ali was pretty quiet the first couple of weeks, but she's such an agreeable dog overall we could tell she was trying to fit in. We think the key was establishing a routine of walking, bedtimes, etc. We kept a pretty quiet house the first couple of weeks so she wouldn't be bombarded with different people. She had one accident, and it was totally our fault—we weren't paying attention. We tried to figure out what she liked and didn't like in the way of toys, bed, food/treats, etc. It was a learning process for all three of us at first.

One of our challenges is that she is not dog-friendly, so we manage where we

walk her–she'll never be a dog-park dog. Which is fine because we just want her to be herself and she seems happy to be an only dog. As time goes by, she mostly ignores other dogs when we walk around the neighborhood. Jim points out that this doesn't limit us in any way–it's not a big deal.

Since Ali was found as a stray, we know very little about her–we don't even know how old she is. We discovered that she knew some commands and even hand signals and is a lady on a leash. We also figured out that when she doesn't know what to do, she'll just sit as if awaiting further instructions, which is sweet. She became more confident and happy as she settled in, but it took a while for us to see her entire personality.

From time to time people will ask why we wanted to adopt an older dog, because we won't have her for a long time. I generally tell people that there are no guarantees in life–we have friends who have lost puppies and young dogs. I also think that if our dogs lived forever, it wouldn't be long enough. Giving Ali a home has been so positive and rewarding; she fit into our lives so easily. We don't ever focus on losing her and refuse to live our lives thinking about the end (this goes for us humans too). We love her more every day, and we focus on making every day count for all of us.

Molly, Mr. Schultz, and Patty . . . and Their Four Kids AS TOLD BY THEIR HUMAN, BRITANY

Jordan and I have been married for almost six years. We have four kids, all under the age of four. Jordan works as an electrical power lineman. His job takes him all over the United States. He currently works away from home 70 percent of the time. I am a stay-at-home mom.

Our first senior-dog adoption was Molly. She was listed as a twelve-year-old Lhasa Apso and in pretty rough shape. We weren't really looking for a dog, but something about her spoke to me. My mom and I packed my kids in the car and drove over to visit Molly at Al-Van Humane Society in South Haven, Michigan. We immediately adopted her.

Molly was the sweetest dog. She was 100 percent my heart dog. She was so devoted to us. She loved going on car rides and sitting in her little Pottery Barn "queen's chair."

We had Molly for only six months. Like many dogs taken from puppy mills, Molly's teeth were terrible due to lack of vet care throughout her life. So we took her to the vet to have dental work done. The day of the surgery her kidney levels (the issue we were most concerned about) were steady enough to proceed. But after the surgery she never really got back to normal. Four days later we had to go back to the vet. Unbeknownst to us, she had a pretty severe form of cancer that the anesthesia exacerbated. Molly had suffered so much in her past life that we refused to let her suffer at all with us.

Molly was so beloved by all of us, but especially my two boys, Lucas and Noah. Every morning Lucas would exclaim, "Hello, old girl! I love you so much!" Noah and Molly were the best of friends. He loved to hold her in his little lap. Even our ten-month-old would get excited when Molly came into her room.

The morning after she died, my little fella kept calling her. Molly and I would come into the boys' room together every morning. Noah kept going into my room to look for her.

Lucas kept telling me that she's still at the doggy doctor and we would go get her. We explained to both boys that Molly is in Heaven and not in any pain. Lucas especially had a hard time accepting that she was gone. However, I do think it really opened up a good conversation about treating others with kindness while they are here, especially the people and animals we love.

After Molly died, we decided to wait until our

house was finished to get another dog. We moved in in December and by January I was ready to look again. At first I thought a puppy might be nice. Losing Molly was so hard for me. We had contacted a breeder and were told no because we had too many kids.

I had contacted a Newfoundland rescue and a general dog rescue, and our vet actually said our local humane society would not adopt to us. So I decided to wait a year after being turned down so many times. I was pretty upset, honestly. I knew we could provide a great home for a dog. However, I decided that perhaps in a year, a rescue might reconsider.

Less than a year later we saw **Mr. Schultz** listed for adoption by Miami-Dade Animal Services. (His original name was Chacal, but my two-and-a-half-year-old has speech apraxia. There is no way he'd be able to say that name!) I saw that he could be transported, so I decided to contact the shelter because I honestly didn't think anyone would take him. He's big, black, and he's old.

And we were approved to adopt! A couple of weeks later Mr. Schultz was transported to our home in Michigan.

Mr. Schultz–we call him Schultz or Schultzy–lives for his kids. We can't even leave the house without him trying to come in the car. I can't imagine him being happy without children. He loves being a family dog and never wants to be away from us.

Schultz is very large, but he thinks he's a lapdog.

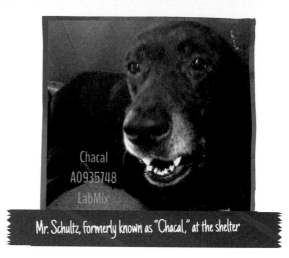

Chacal
A0935748
LabMix

Mr. Schultz, formerly known as "Chacal," at the shelter

The children roll toys over him and put fire hats on him daily. He rolls on his back and waits for belly rubs. If they accidentally bump into him, he licks them. If Scarlett tells him to go away when he's begging her for food, he goes. This might sound like we do not respect his space, but Schultz does not want his space. We have to shut the playroom door or he barrels his way in and lies on the kids and all of their toys.

He goes up every night to do bedtime with me. First he lies down in Georgie's room for stories. Then he visits Scarlett's room. Finally he goes to the boys' room. He will not come downstairs until they are fast asleep. He really is connected to them.

The main reason we got another dog after bringing Schultz home is because of how much he was thriving here. I knew if we could get an arthritic dog, one who initially could hardly make it out the door,

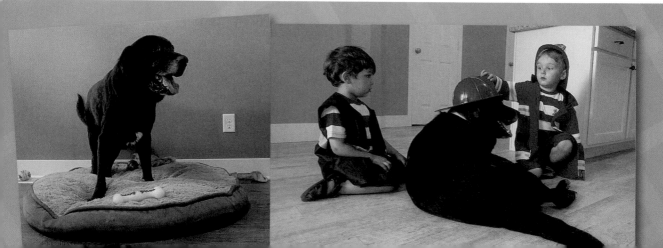

This picture shows when we know Patty wants to be petted. She looks at us and scoots in. She will move away the minute she's done. And we let her go.

"running," we could give another dog a great start—or rather, finish. And Schultz is so friendly that I knew he'd like to have a buddy.

We brought Patty home, also from Miami-Dade Animal Services, four months after adopting Schultz. Patty is twelve years old and very reserved. She loves having a warm bed, reliable food, and people who give her a nice gentle pet. However, she does not like to be all over the kids.

When Patty lies on her bed, which is placed by the door away from the closed playroom and the couch that the kids watch TV on, we don't bother her. Patty's bed is her special quiet place. We have also taught the kids that when petting Patty, if she moves away (which she does pretty quickly), petting time is over. She is more devoted to me than the kids.

We have always told the kids that we adopt "old-timers." Our old-timers sometimes hurt more than puppies, and sometimes they need a nice rest. Sadly, death is a part of life. We are really into keeping an open dialogue about it. It's the same reason that I wouldn't hide a grandparent's death from my children. Life can change in an instant. It seems silly to me to not allow kids to get close to someone just because they are older and therefore closer to death. I feel the same way about senior dogs. I would much rather my children experience the joy of having a dog and learn about the kindness of saving a helpless animal, even if that means some sadness goes with it. The kids were able to get past Molly's death because we still talk about Molly and we look at pictures too. I believe the ease of a senior dog really outweighs the fact that eventually they will die. A senior dog is really a perfect dog for a young family. They don't require as much work, but they give so much love.

Koby's Story
As Told by His Human, Christine

Before I adopted Koby, I never owned a dog, and in fact my family doesn't even like dogs. After reading two books about doggy care, I threw myself into the adventure of fostering. I figured that'd be a low-commitment way of trying out how all of this would work. I was not going to adopt a dog. No way. I had a very difficult year behind me, with many personal ups and downs. In addition, my mom was terminally ill, and there was nothing to be done. To see someone close to me suffer and not being able to help is incredibly hard, and the only thing I *could* do to stay sane was to take all that emotional energy, all the crying and despair, and put it into something positive. And that was Koby. I didn't rescue him–he rescued me. During a time of challenge and change, he was the constant in my life. He was the little pair of eyes that would look at me and say, "I love you, please take care of me," no matter what happened.

When I began to foster Koby, a nine-year-old shih tzu mix who was found as a stray, the first few weeks were a little surprising, to say the least. Nobody had told me that newly neutered dogs would mark everywhere–indoors, outdoors, everywhere. Nobody told me that even house-trained dogs would poop and pee indoors if they are stressed. And Koby was stressed–he had just lost everything he had! None of the books I read had said anything about adopting a rescue with lots of separation anxiety. I walked Koby four or five times a day, and would still find a wet spot somewhere at home whenever I left him alone. And he wouldn't sleep at night. And he would wake me up early in the morning. I was getting exhausted. Typical new-mom syndrome, I would say in retrospect.

However, three weeks into the adventure, I noticed that I didn't want to put Koby's *Adopt Me* vest on anymore. I didn't want to take him to adoption events. I was getting sad at the thought of someone else taking care of him. I had fallen in love with the big eyes looking at me every time I did something, the little guy following me everywhere, the wagging tail and excitement every time I came home, his learning new tricks to get more food or just being happy to lie on my lap. I had fallen in love. And all of that made the sacrifices worthwhile.

I adopted Koby shortly after realizing this, and it's been the best decision ever. There is just this infinite amount of love you gain from helping a little being trust the world again. You simply start to reprioritize–there are no quirks, really, because who's perfect anyway?

CONNECT: ⊙ @KOBYDOGTHEADVENTURER

susie says:

I'm not the only expert on senior dogs. My friend Dr. Koby Doggy Sr., graduate of the University of Adopted Senior Dogs, answers the top five most frequently asked questions about adopting an old dog. Take it from Koby—he's a professional adoptee!

ask koby about senior dogs:
The Top Five Most Frequently Asked Questions

Dear Koby, I love dogs, so I can't bear the thought of losing my dog after only a short while. A puppy would live so much longer! —S.

Dear S.,
Yes, it always makes me sad to lose a doggy friend. But you know, even puppies grow older and will die someday. Then we go to the Big Eternal Farm and have peanut butter and cream cheese all day long. But before that, we would like to live a happy life— and that does not know time. Days are years, years are days. You'll be grateful for all the time you spend with your dog, no matter at what age you find him. —Love, Koby 🐾

Dear Koby, I want a puppy because then I can train the dog to do what I want. The right fit is really important to me! —N.

Dear N.,
Since there are millions of us at the shelters, you can find any type and character of dog you could want. If the perfect match for you is important, then try fostering first. My mom really did find me by accident (she wanted a big dog and I am small!). I was simply the dog they had at the shelter when she stopped by. And then she fell in love. For her, I am perfect— including my imperfections! —Love, Koby 🐾

Dear Koby, I want to adopt a dog, but I think a senior dog costs too much money because of the frequent visits to the vet. I can't afford that. —B.

Dear B.,
Think of all the emergency vet visits when your puppy ate the wrong thing or your teenage dog got hit by a car—what about that? We senior dogs are happy to live a very healthy and safe life on your couch. —Love, Koby 🐾

Dear Koby, I would adopt a dog, but it's impossible— I travel too much. —A.

Dear A.,
That's exactly what my mom thought! But think of this: Senior dogs, because we need less walking and other entertainment, are WAY easier to find sitters for. By now, there's a waiting list of people who want to look after me when my mom travels. ☺ —Love, Koby 🐾

Dear Koby, I am still not sure. —X.

Dear X.,
That's okay. Just go to a shelter and have a look. Maybe help out by taking the dogs there for walks. Or foster a dog for a few weeks. As a responsible person, of course you would think about having a dog before actually getting one. Thank you for doing that. But once you have thought about it, just go and do it. Save a soul. Really—it'll be fine. —Love, Koby 🐾

Gretchen and Merlin's Story
As Told by Their Human, Kelly

THANK YOU FOR BEING A FRIEND . . .

Some animals have best friends, and it's not uncommon to find bonded dogs at animal shelters. If separated, bonded dogs can get very depressed, and may stop eating or even fall ill. It's hard enough to find a home if you are a senior dog, but it is doubly hard to be adopted as a bonded pair. And a senior bonded pair? Well, that can be near impossible.

Gretchen and Merlin are known as the Odd Couple. Gretchen is a fourteen-year-old, 120-pound Rottweiler and Merlin is a ten-year-old, 15-pound fox terrier. Gretchen and Merlin were surrendered to the shelter when their former owner moved into an assisted living facility—a heartbreaking situation for all. Shelters and rescues will try their best to adopt out bonded animals together, but that's not always possible. So when Gretchen and Merlin found their home together, it was a miracle!

THE ODD COUPLE

TWO is better than one ♡♡

ringing home two dogs when I already had two and knew I was going to be going through in vitro fertilization less than a month later had its challenges. It still does! But when I saw Gretchen and Merlin's photo on Susie's Senior Dogs, I thought, "No way will they ever get adopted. No one wants an old Rottweiler." I wanted someone else to have emailed about them, but I was the only one.

Gretchen and Merlin deserved a chance, and it meant more to me that they needed each other. They were a duo, and I accepted that from day one. Everyone thought I was crazy. And I was. Four dogs. A cat. Toss in two babies. But we make it work. I've learned who can be left alone together and who can't. Gretchen torments my corgi when I leave, so they get separated. Sometimes she goes crazy and chews my shoes.

Gretchen is also massively arthritic. Maybe no one knew because she never got exercise, but it was exposed immediately the first week I got her outside. She blew out her anterior cruciate ligament running like a puppy through the snow in February. (You'd never know it now because most of the time she zips around.) Meanwhile, Merlin attacked a bear in April. I still have no idea how he survived. The process of integrating Gretchen and Merlin into our family hasn't been seamless, but it was important for me to make this work.

I've now had them over a year. Gretchen has lost a ton of weight going on walks every day. And who knew that Merlin is obsessed with chipmunks? Now that the snow has melted, he and my beagle will chase chipmunks for hours.

I felt it was almost easier taking the two at once, because at least they had each other. I can't imagine how sad and scary their lives were, but it's my goal to give them the best future I can.

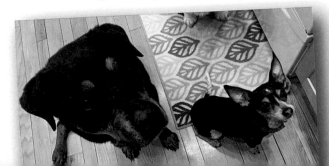

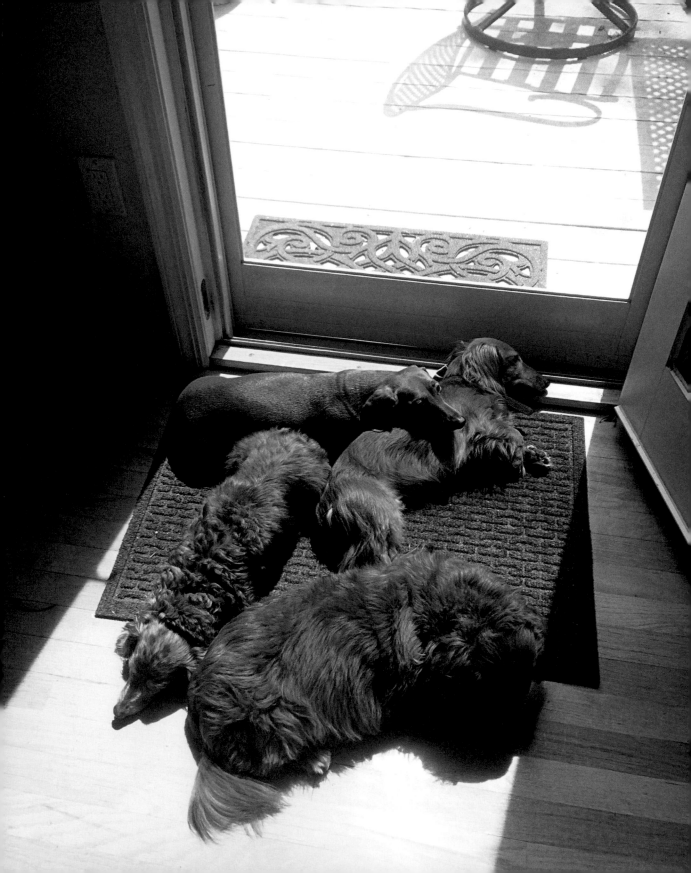

Four Dachshunds AS TOLD BY THEIR HUMAN, HELENA

Our family has always loved animals, with dogs being our absolute favorite. First was Charlie, a 110-pound golden/lab mix, followed by Amelia, a ten-pound miniature dachshund. When Charlie died just shy of his twelfth birthday, we added Arthur, another mini dachshund. Two dogs worked well with our family, and we felt we could handle one more, especially if they were small, like Amelia and Arthur.

Our mother was emphatic that the next dog not be a puppy. She felt the days of house-training and discovering chewed shoes and furniture were behind her. We visited pet-store adoption days and perused online sites, and it became apparent very quickly that there were many older dogs that needed homes. So our focus became an older or senior dog, one that might not be very cute, might even be funny-looking; one that needed us as much as we wanted him–the quintessential underdog!

We visited shelters and looked daily for a dog who seemed right for us, but fate intervened at the dentist. Yes, our human dentist, whose receptionist was a frequent foster mom for a rescue group in

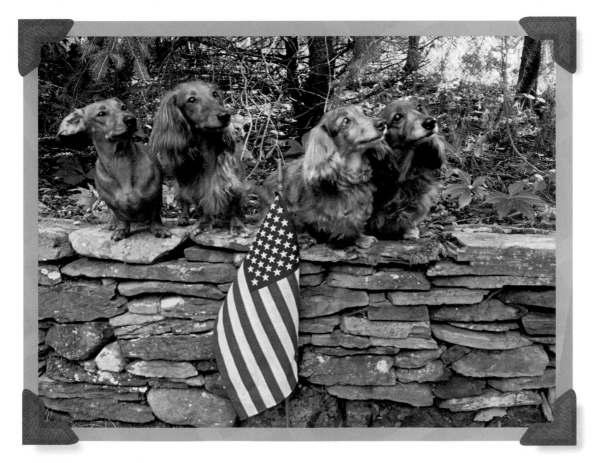

our area, Cold Nose Warm Heart Dog Rescue. She showed us a photo of two female dachshunds who had been transported from Virginia to New Jersey, when their owner was forced to surrender them due to her poor health. They were beautiful twelve-and-a-half-year-olds, in good health, and free to adopt as soon as they were spayed. The only caveat was they had to be adopted together–both or neither. They had been together their entire lives and were best buds, a truly bonded twosome.

Two senior dogs did seem a lot to take on, especially with two dogs already at home. What crazy person has four dogs? Friends and family quickly offered their unsolicited opinions: "They're too old." "They'll die soon and you'll be sad." And there was always the favorite: "You'll have so many vet bills!" All the naysayers did put us off a bit, but not enough to stop us from going to meet Annie and Heidi. They were ours at first glance. We decided to be that crazy family with four dogs.

Deciding to adopt Heidi and Annie was easy; we knew the real work would be having all the dogs live together peacefully. Heidi and Arthur were naturally easygoing and happy to be followers. Annie and Amelia were the challenge, as both tried to exert their dominance, and it took time, patience, and a lot of creativity to finally get them to work together. Food problems were avoided by always having someone sit with them as they ate. When one dog was finished, he or she was gently

directed out of the kitchen to allow the slower eaters to dine in peace.

When someone from the family entered the house, both Annie and Amelia would run to be the first to greet them, and a round of nips and growls would ensue. We finally developed a system where no one was greeted or petted until all dogs were calm. Then each dog's name was called out, and that particular pup had its moment of petting glory. It was slow and wearisome in the beginning, but it worked for both them and us. Eventually anyone could enter the house and it was a free-for-all–but a fun, well-mannered free-for-all!

We adopted Annie and Heidi in March, and the following January, Heidi was diagnosed with inoperable liver and splenic cancer. We threw most rules to the wind and spent days doing what Heidi loved, which was simply doing things together. We went on long car rides (even visiting her first mom in a nursing home in Virginia), sat for endless hours having couch time, and when spring came, we went outside and Heidi watched the birds, her favorite activity of all. Crows, she especially liked.

On a beautiful April day, Heidi died, but not before having one more long ride in her stroller, as she could no longer walk around her beloved park. Though it was obvious she was slipping away, she was a queen that day. Local schools were off that week, and at every turn we saw people we knew,

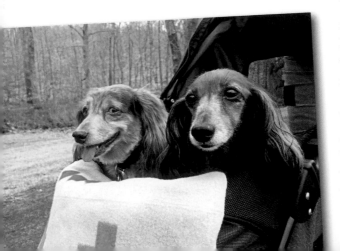

who ran up and kissed and stroked her face. She left this world knowing only love.

Our next hurdle was helping Annie to grieve. We had lost our sweet Heidi, but she had lost the only constant in her life. To this day, we envelop her with love and attention. Annie seems to have lost a little zip, but who knows if it is from sadness or age? Probably a little bit of both.

Some changes we observed in Annie's behavior immediately after Heidi's death were blamed on aging or dog depression, especially her reluctance to go on walks and her sleeping more. Yet a real red flag went up when she stopped eating—Annie is normally a voracious-equal-opportunity eater. She'll eat anything, anytime! Blood work diagnosed Lyme disease, and she started a monthlong course of antibiotics. Within days of starting the medication, we saw the old Annie reemerge—but even better! Her appetite returned, the pep was back in her step, and she was playful. It made us suspect she had felt lousy for a long time, and it was wonderful for her to feel good again!

Annie also forged a close bond with Arthur (who was petrified of her when she first arrived). They often sit together quietly or roughhouse over a toy. Amelia remains the pack leader and is protective of both Annie and Arthur. Annie rarely barks, but makes a vocalization that is part shriek, part wail, and a lot of whining. We hardly ever heard it until the last few months, when she wants to get on the couch or off the bed or into the front car seat, or would like to have what you're eating. It is an irritating noise when done at a low volume; when it is loud and insistent, it is maddening. Annie uses it (too) often now, as she has become confident in our love and her place in the family. She's home. ♥

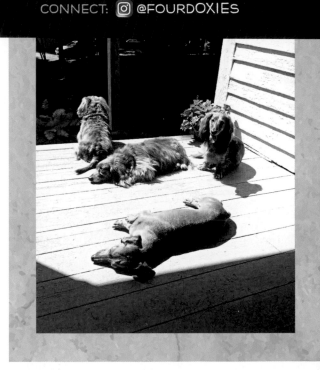

CONNECT: @FOURDOXIES

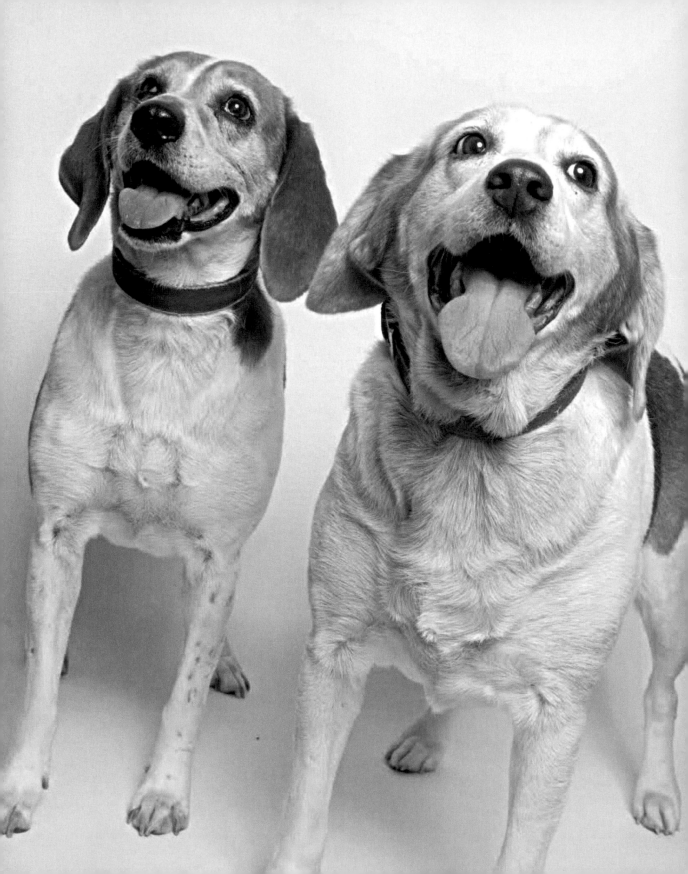

Rosy and Daisy's Story
As Told by Their Human, Robin

I'm a cat person. In 1998, I bought my first home and moved in with my two cats. In 1999, a friend was looking for a home for a dog she knew, and while I couldn't take him because he didn't like cats, it did make me realize that I had the room and the time (I was working from home) to save a dog from the shelter. My friend tried to steer me toward a senior or at least a somewhat older dog, but I convinced myself that a puppy would be the least objectionable to the cats. "If the dog is at least smaller than the cats at first, it will be less traumatic," I told myself. And then I saw Potter, a puppy in foster care at Seattle Animal Control. I immediately knew he was my dog. A couple of weeks later, I picked him up, and we were pretty much inseparable from that day on. I lost Potter after fifteen years to old age and liver cancer. I swore from that day on that I would never–NEVER–adopt another dog. I have to travel for work and it's expensive to leave a dog. And dogs are just SO much work. I missed him dearly, but I tried to convince myself that it was just going to be so much easier without a dog to worry about.

And it was easier. But it wasn't better. A house isn't a home without cats; a home isn't alive without dogs. Somehow a dog manages to fill an entire house with its presence.

And then I saw Rosy and Daisy and it was love at first sight. They were listed as hound mixes, six and seven years old, and the very best of friends. I saw their picture on SSD, saw that these beautiful girls had been at the Gloucester-Mathews Humane Society for over two years, and I emailed. I somehow managed to believe both that they were MY dogs and that I'd never be chosen to adopt them. I am in Bremerton, Washington; they were near Richmond, Virginia. It was mid-September and I couldn't adopt them until late October due to some already scheduled business trips. (I didn't want to bring them home and then leave right away.) "Surely," I thought, "someone else will fall in love with their picture. Someone closer will want them and that will be it." But no one else did. It was up to me.

I happen to work for a company in Maryland, and my late-October business trip was to Baltimore. I had a direct flight back to Seattle from BWI, so I booked the dogs on my flight home. As they still had another month at the shelter, I mailed some blankets that the cats and I slept on so the dogs could learn our smells. I went on shopping sprees, buying everything I could think of for the dogs to travel: crates, food, snacks, leashes, harnesses. I mailed things to the office, like towels and blankets for their crates.

When we got home, it really was chaos at first. They were in a completely new environment and it was clear that they weren't completely accustomed to living in a home. Neither of the dogs knew how to go up or down the stairs. They were afraid of mirrors. Both of them seemed interested in peeing outside, but neither seemed

to know how to tell me it was time to go out. They wanted to chase cats, sometimes barking and frantic. They couldn't stand to be out of each other's sight and I let them be each other's security blanket as much as possible.

Daisy is the more timid, the more determined to please, the more vocal, and oddly, the more independent one. It's like she's so happy to finally have the comforts of being allowed on the couch or bed, and she's going to take every advantage of it. She doesn't care if I'm upstairs in my office—there is a whole bed to sleep on! I've been trying to teach her some basic training, but it's hard to get her to calm down enough to understand the commands because she's so eager to please.

DAISY

ROSY

Rosy, on the other hand, isn't doing anything unless she wants to. If she wasn't spoiled before, she's making sure her true nature is satisfied now. She's not shy about letting me know what she wants, and she won't do what I ask unless she can pretend it was her idea. Contrary to Daisy, Rosy is not interested in pleasing anyone but herself.

That Rosy and Daisy were at the shelter for over two years is insane. For the first three months they were here, I literally got daily compliments on what beautiful, sweet dogs they are. And I don't just mean comments from people as they walked by either. In one week, I had a woman stop her car and back up the road fifty feet so she could tell me she loved my dogs; I had a woman ask me if they were available for adoption; I had an old woman at a senior center force other people to detour around the block because she was ignoring the honking and she wanted to hear the rest of the story of Daisy and Rosy; and I had a bus driver stop his bus—with passengers on board—so he could get off the bus and pet the girls. I still get comments at least weekly, but otherwise the girls are a fixture in the community and the compliments have turned into greetings.

Rosy never doubted that this was her house. She marched in, made herself at home, and assumed I would fall in love with her (I did). Daisy, by contrast, couldn't allow herself to trust that this was forever until she'd been here for about six months. She went from being very quiet and unassuming to bouncing around the house with a constant happy chatter. On our morning walks around the neighborhood, Daisy prances around and barks happily at everyone we see.

Nearly one year later, we have a routine and we're all one big happy family—human, dogs, and cats. It's weird to think that it's been only a year since I made the decision to adopt them. It feels like they've always been here. They certainly always belonged here. Thirteen months ago, I said, "No more dogs." Now I can't imagine this house without these dogs in it. Simply put: It's love.

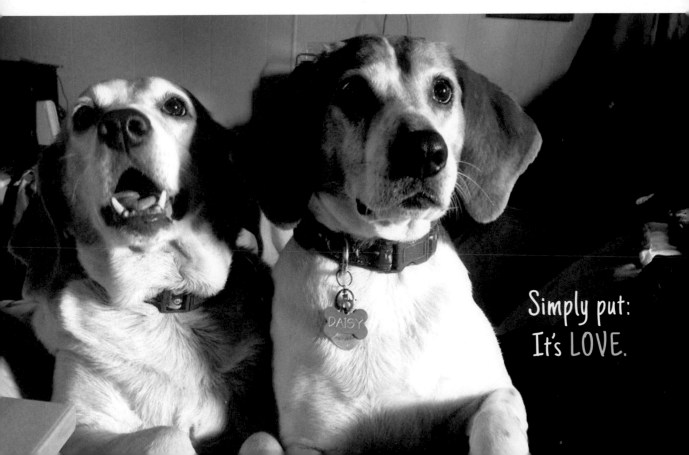

Simply put:
It's LOVE.

Deckle's Story
AS TOLD BY HIS HUMAN, MAGGIE

I was killing time on Facebook on a damp December weeknight when a new post popped up on Susie's Senior Dogs. I had seen lots of pale snouts, sad eyes, and even sadder stories, but something about the pup on the screen grabbed my attention, particularly since he had been marked to be put down and was ill as well.

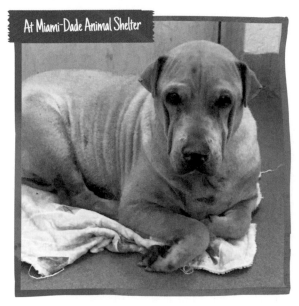

At Miami-Dade Animal Shelter

I got up and took a shower, but the usual holiday-related thoughts and end-of-the-day fatigue were crowded out of my mind by those gloomy brown eyes I had seen on the screen. I went to my husband and explained that this senior dog's story was giving me no peace. With his support, I emailed the shelter volunteer. In a way, we didn't choose Deckle; our paths crossed, and it seemed the most natural thing in the world that a week later he was drooling contently in my lap.

Deckle arrived on Christmas Eve 2014 with a whopping case of kennel cough and a heartbreakingly sad look on his face. He kept his head down and his tail was motionless. It took him awhile to warm up to us and to realize the cat was not out to get him.

We visited my mother for Christmas the next day. I have never met an animal that wasn't smitten with her instantly, so she was an appropriate first visit. He accepted treats from her, promptly shed all over her couch, and swiped a turkey bone from the garbage. To this day, Deckle seems to know he can get away with murder at his grandmother's.

Once Deckle had been to the vet for his cough and cold, and his appetite improved, we began to see where his caution was originating. He was paranoid about the cat getting near his food, and swiped garbage whenever he could. It took a couple of months for him to realize that no one would take away his food. But owning pets is not just for selfies and brownie points; there're messes and vomit and middle-of-the-night accidents. We had adopted him and were going to stick it out.

Now he's like a different dog. He literally bounces with joy when we get home from work. One of his nicknames is Cuddle Glutton, a far cry from the timid, watchful dog we first met. Where he once lagged after half a block of walking, he

now prances along at record speed, his nose to the ground. I think one thing that deters people from adopting shelter dogs is a misconception that they come with baggage. To see Deckle's sweet gray-muzzled face every day is a joy, and if we had dismissed him out of hand on the grounds of being a shelter mutt, what a loss that would have been.

I think the cautions and advice of shelter staff should always be taken seriously. I suspect that there's a misconception that a "new" or very young dog would not have the initial issues and fears that Deckle was originally crippled with. That's foolish; Deckle's issues were based on his life before we found each other instead of being the health and behavior issues one sees with trendy pets and inbred breeds. Dogs of all kinds respond to love, patience, regular meals,

and exercise. Owning a senior dog should be approached with seriousness but also with the realization that dogs with gray snouts and scars are often puppies at heart.

Eight months after his arrival, Deckle is perfectly happy to let the cat share his water bowl; he'll eat almost anything, more out of good-natured gluttony than fear of starvation. He is shy but gentle, and has a long list of admirers. The trash is his weakness; we usually keep it covered to avoid temptation. He's not perfect, but neither are we; we're a pretty great match. The only other surprise we've had since adopting this sweet fellow is how much we've come to love him. He's silly, good-natured, gentle, and spoiled. As is true with all pets you share your life and home with, sometimes you wonder who saved who!

❤ UPDATE! ❤

Maria arrived on August 14 at 3:24 p.m., weighing in at 6 pounds, 13 ounces and measuring 17½ inches. Deckle is her guard dog. He's always within a few feet of her, and if we don't respond quickly enough to her cries, he'll come find us. I think Deckle was originally confused about Maria's presence, but he is now devoted to her—he'll stick his head right in her bassinet to check on her!

Susie's Mission Grows

When Susie's Senior Dogs obtained its 501(c)(3) nonprofit status, this created more opportunities to support senior dogs and the shelters, rescues, and sanctuaries who care for them. Monetary donations to SSD are used to directly impact the well-being and quality of life for older dogs, anything from sponsoring adoption fees to vet care and special surgeries a senior dog may need. This is not only important for their health, comfort, and increased life-span, but it also makes them more adoptable to the general public. Even if you're not in the position to adopt or you don't have time to spare for volunteering, many shelters and rescues provide the opportunity to financially sponsor individual dogs and their specific needs. This is a great way to help give a senior dog a second chance!

Because education and awareness are so vital to create lasting change, teaching young people is a very important part of this process. As the SSD community grew, I began thinking about how to share what I was learning with a younger generation. I started locally by creating an after-school Animal Club for New York City middle school students. The Animal Club is open to any students interested in learning more about our animal friends. It has two major goals: first, to provide students with a learning experience that demonstrates the importance of animal welfare and the humane treatment of animals; and second, to introduce them to various career opportunities related to working with animals.

I believe that humane treatment of animals is best learned from our surrounding environment. The sooner we can educate young people about the value of animals and the respect they deserve, the greater chance we have at protecting them and controlling the current overpopulation of dogs and cats in the United States. The Animal Club has toured the New York City public animal shelter, a local animal hospital, the NYPD K-9 training facility, a wild bird hospital, and a wolf conservation program. We even spent the night at an animal farm sanctuary!

NYPD K-9 Training Facility

Brooklyn Animal Care Center

Catskill Animal Sanctuary

The following story is about a little girl who was born with an exceptional love for animals. From the time she was very young, Catherine displayed an inherent kindness toward all creatures—dogs, cats, birds, fish, it didn't matter . . . she loved them all. At just six years old, Catherine was wise and compassionate beyond her years and was already deeply committed to tenderly caring for our voiceless furry friends. She even designed her own business cards and appointed herself "Care Taker" at "Catherine's Animal Shelter," an imaginary refuge she hoped would one day become a reality.

Tragically, Catherine lost her life to gun violence on December 14, 2012, in the Sandy Hook school shooting. But today her family is making her dreams come true by opening the Catherine Violet Hubbard Animal Sanctuary, a place where unwanted animals can find refuge and safety. The sanctuary will continue to spread Catherine's kindness and compassion and work to educate other young people about animal welfare—just as Catherine would have done.

For the Love of Animals

Catherine adored animals. Feathered or furry, slimy or scaly, she loved them all unconditionally. They were her life, her true love affair. Before she could walk she would scoot across the floor to be nose to nose with our dog, Samantha, or "Sammy." Before she could manage a full sentence she tasked Santa with bringing her two fish. She would bargain for a new stuffed animal at every opportunity, and when she did manage to add one to her collection, it became part of the mix that surrounded her in bed. Sometimes the pile would get so high, we'd have to sift through it just to find her cheek to kiss her good night.

Catherine's nature was simply to be kind to all animals. She told us one day she would have a place for all the animals, even going as far as creating business cards for her imaginary shelter. She'd take bottle return money and buy a box of dog biscuits for the animal control center. When we visited a nearby stable, she'd stroll through the barn, stopping only to stand on her tiptoes to gently stroke a velvety nose extending out of a stall. I will always picture her cupping a beautiful butterfly in her tiny hands. She'd whisper to it as it took flight and tell us it was going to tell its friends she was kind and they would come back. Not surprisingly, we were mesmerized by the flocks of butterflies nestled in our gardens.

Sadly, her gentle whisper was silenced on December 14, 2012. A gunman took the lives of six adults and twenty children at Sandy Hook Elementary. Catherine was among the children killed. So much was lost that day—Matt and I lost our daughter; my son, Freddy, lost his sister; the world lost its innocence. In the time since, though, we have found things: love, support, kindness, and community. We have found hope and a new purpose.

Catherine can't whisper her secrets to the animals anymore. She can't spread her message of kindness or care for the animals that need it, but we can. We are Catherine's butterflies. We are her messengers. We carry her voice, her hopes, and her dreams and will create a place where her kindness will be felt not only by all creatures but also by every person and community it touches. We will realize Catherine's dream through the Catherine Violet Hubbard Animal Sanctuary.

The sanctuary is a beacon of hope that embodies the beauty, optimism, and purity of Catherine's love for animals. It will be a place where animals displaced when caregivers can no longer provide for them will find shelter. Abused or neglected farm animals will find rest and refuge. Injured wildlife will receive healing support until they can be released into their natural homes.

The sanctuary will be a place for community to connect, share, learn, and grow. The expansive meadows and trails provide quiet places to reflect and dream. Classes

focused on the arts will encourage imaginations to explore unlimited possibilities. In teaching the community how to care for animals and the environment, we believe we will help everyone grow in compassion and acceptance and in turn make the world a little kinder and gentler for all.

As people visit the sanctuary, whether they are exploring its natural beauty, participating in its programs, or caring for the animals that live here, we hope they feel Catherine's presence. We hope all creatures will know that here they are safe and humans are kind. We hope children will know compassion, and see their own innate beauty in the eyes of a lamb, deer, or kitten. Here, we hope the world sees how peace begins: through love, respect, and kindness. At the Catherine Violet Hubbard Animal Sanctuary we will all heal, together.

One of my favorite programs from Jenny and Matt is the Senior Paw project. It's a collaboration between the CVH Animal Sanctuary and their local shelter, Danbury Animal Welfare Society (DAWS), that specifically focuses on the homeless senior dogs in their community. Through a network of special caregivers, the senior pets who arrive at DAWS are given priority to move into a foster home, rather than living in the shelter while they wait for an adopter. This is such a great initiative for our most vulnerable furry friends!

Catherine loved Samantha so much. When Sammy's arthritis got the better of her, Catherine often tried to help her dog to her feet, even though Samantha was heavier than she was.

CONNECT: @ @CVHANIMALSANCTUARY
f /CATHERINEVIOLETHUBBARDANIMALSANCTUARY

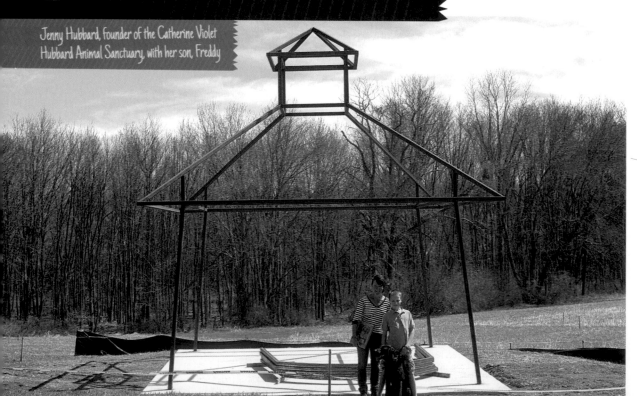

Jenny Hubbard, Founder of the Catherine Violet Hubbard Animal Sanctuary, with her son, Freddy

Buddy's Story AS TOLD BY HIS HUMAN, MELISSA

I joke about taking on lots of big changes at once, like moving to a new city and starting a new job and celebrating a milestone birthday all in the same week! Or the time I had spinal surgery and bought a house a few weeks later. In the case of adopting Buddy, I was in the process of buying a new home on my own, and faced some uncertainty in closing and moving dates.

Paris and I had been together for a few years, but she was alone all day while I was at work, and dogs are supposed to be pack animals, right? So I had been thinking about expanding our little family, but the timing was key–it had to happen after the impending move.

I saw Buddy's adoption feature a few weeks before I was due to move, and decided to go down to the shelter just to meet him, see if there was a connection. He was so sweet and gentle, but I really tried to stay emotionally detached. After all, his story had been publicized on Susie's Senior Dogs, so there must be lots of interest. He would find a good home, mine or another. Unlike the eagerness I'd felt when I scooped up Paris, I had a different approach with Buddy. It wasn't the same kind of urgency for two reasons: I was on the cusp of upheaval with my home, and ultimately it would not be my decision. It would be up to Paris and how she reacted to him.

When I first saw Buddy's picture and profile, he resonated on a few levels: He is a shih tzu (Paris is part shih tzu) and older (Paris is also a senior dog). The real key would be finding a dog with a personality that would work; Paris is an alpha dog and

PARIS

any companion would have to have a nondominant personality. I soon learned that Buddy is rather shy and introverted, and that gut feeling kicked in, when you know that's the dog you want to bring home. But I still had to see how Paris liked him.

I thought of Buddy a lot over the following weeks. And after my move was complete, I went back down to the shelter to see if he had found a home. If he was still available, then maybe it was fate. As luck would have it, he was still in need of the right home to fit his special needs (quiet, no stairs, a human to give him eye drops three times a day). My home fit the bill, so it was time to meet the decision maker, Miss Paris herself. The Humane Society of New York brought him over and we introduced the dogs in the park. We then took them up to my new apartment and spent some time seeing how they interacted. They mostly ignored each other, with an occasional curious sniff, which we took as a sign of possible success.

In hindsight, I think his special needs, medical issues (heart condition, very few teeth, one eye, some deafness), and probably his age all could have deterred potential adopters. People may have looked at him and seen a giant medical bill. I'm lucky that I don't have a lot of financial responsibilities beyond my personal needs, and I thought, "I can give him that level of care–I can rescue an old dog who has medical needs."

I am a firm believer in the idea that you don't find the right pet, the pet finds you. They speak to you. You see a photo or meet them in a shelter, and your gut says "That's the one."

The timing for me in finding these two amazing dogs just happened to coincide with other big life changes. If you are actively looking to adopt, you don't necessarily get to choose the time to meet the right pet. Before Paris, there was another white fluffy dog, a Lhasa apso named William. I wanted to adopt him, and someone else beat me to it–I was heartbroken. So when I saw Paris's photo on the San Francisco Animal Care and Control website, I was there that same day to meet her and take her home.

Buddy, Paris, and I have now all been together for more than a year. It's not perfect–I need to ensure they are fed in separate spaces, and Paris still likes to dominate for attention. But because Buddy is such an easygoing dog, it balances out Paris's big personality. He is not competitive, and that is part of what makes it work.

Despite his medical issues Buddy is a happy little guy. He loves to snuggle, and he's content to have his bed, a few toys, chew sticks, and the company of his canine sister and his human. And belly rubs, of course. I love him more every day, and I'm so happy I get to host his retirement years–I get to be his custodian. We both won the lottery.

BUDDY

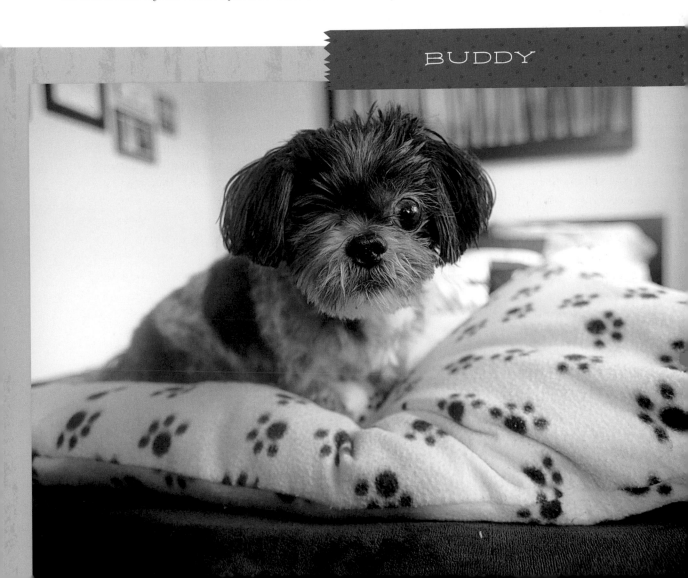

Fostering: WHEN HOME ISN'T A FOREVER HOME

Fostering homeless dogs and cats is a critical element of animal rescue. Those who volunteer a spot in their home for homeless dogs or cats play a huge role in saving the lives of shelter animals. Fostering serves an immediate need by providing additional space when a physical shelter is overcrowded. But foster homes also play another crucial role by providing a healthier, more suitable environment for the animal and offering insight on the animal's unique personality, behavior, and habits while he or she waits to be adopted.

Many people find traditional shelters too sad to visit, and seeking a foster dog for adoption is a great alternative. Potential adopters are often able to meet a foster dog at a location outside of the shelter environment, which may be a more relaxed scenario for everyone. Do not be deterred if the dog you're interested in appears to be aloof or even attached to the foster parent. All animals have different personalities, and some may attach to humans quickly, while others have been through so many changes that they need awhile to warm up to a new person. Whatever the situation may be, keep an open mind and employ a lot of patience in your search for your next best friend. He or she is out there, and it's just a matter of finding each other.

Susie has welcomed a handful of foster dogs into her home, and while there is always an adjustment period for everyone, each one has been successful in the end.

Inkie, a ten-year-old "miniature fox mix" (as we jokingly labeled her), immediately settled into our home environment without missing a beat. We didn't know much about her past, but she quickly caught onto the routine when it came to bathroom breaks, eating schedules, and sleeping

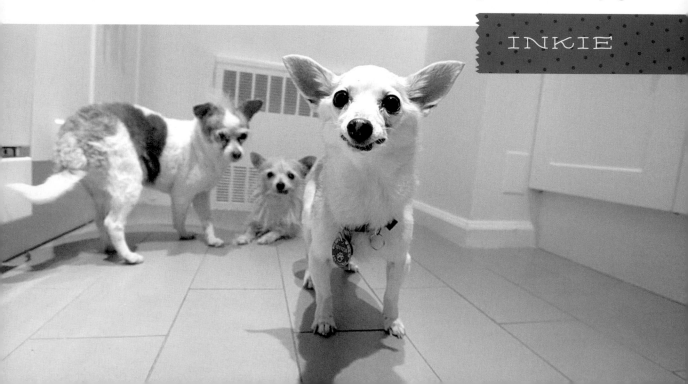

INKIE

patterns; it was as if she had known it all along. Within twenty-four hours of being with us, Inkie started following both Brandon and me around the apartment as if she'd been part of our family her whole life. It would have been easy to keep Inkie as our own pet rather than adopt her to someone else. But I knew that somewhere, a great family deserved a great dog like Inkie, and keeping her for our own just didn't feel right. I am thankful that we were able to give Inkie a comfortable setting while she waited for her forever family. Just one week after we fostered her, Inkie landed herself two amazing parents, a dog sister named Zoe, and a cat brother named Goo. And best of all, she has her own Instagram account, which I frequently stalk! :-)

We were equally excited about the opportunity to foster Blue, a pit bull puppy who was being promoted for his "breeding potential"

on a sidewalk in New York City by a man who was willing to give him to anybody. We took Blue from that situation and fostered him through Animal Haven to ensure he would receive proper vet care (and get neutered–there are already too many homeless puppies). This also allowed us to find him a home through a reliable adoption screening process. Because of his pit bull breed, Blue (and his potential offspring) could have easily become another shelter statistic. Just two weeks into his foster stay with us, Blue was adopted by two wonderful humans and their resident dog, Bear. Blue has since grown up to become a well-socialized, well-behaved boy who is the perfect advocate for pit bulls!

Why I Foster

CHERYL WEST

ostering is an integral part of the rescue world. To foster a dog is to open your home to a dog from a shelter or a rescue for a period of time and provide him or her with a temporary place to live. The time varies—it may be until the dog is adopted, or just until it is healthy enough to be made available for adoption. Many rescue organizations rely solely on foster homes to house the dogs they pull from shelters. Many shelters have organized their own foster programs because it allows them to save more lives. When a dog goes into a foster home, it opens up kennel space for another dog; this is especially critical in open-access shelters with high euthanasia rates due to space limitations.

Pregnant dogs or nursing moms and litters are often fostered so that they have a quiet and disease-free place to stay until the puppies can be weaned and placed for adoption. Dogs who are sick are often fostered while they receive medications and recover from things like respiratory illnesses, surgeries, or mange; the low-stress environment of a quiet home helps speed healing and improve their outlook. Dogs who are frightened or need socialization are often fostered to build up their confidence in order for them to be adoptable. And of course a dog can be fostered just because of space issues in a shelter or rescue group. In these cases, feeding, spending time with, working on basic training or reinforcing what is already known, and caring for the dog are all that is required until the dog is adopted.

I began fostering in early 2013 and have fostered over 120 dogs and cats in that time. But I did not set out to foster. I didn't even know what fostering dogs meant or why one would do it. I live in Chicago proper, but teach

high school in an impoverished south suburb. In December 2012, I became aware of the South Suburban Humane Society in Chicago Heights, Illinois, because they had taken custody of the Dolton Seven, seven dogs who were rescued from a dogfighting operation in the town where I teach. Being an animal lover and feeling a connection to the location, I followed the story. At the same time, as a single mom, I was looking for something to do with my thirteen-year-old son that we would both enjoy and that would instill in him a sense of service.

So I decided to check out the South Suburban Humane Society, and after a training session, we began walking dogs and petting cats a couple of times a week. We loved doing it and fell in love with this little shelter, which was making innovative changes to save more lives. I was looking for more ways to help as I learned more about the plight of homeless pets, shelters, and rescues—luckily, the shelter was organizing a formal foster program. The SSHS was open-access at the time, so taking any dog into foster care opened a kennel for someone new. The foster staff provided me with an informational packet and support, and I took home my first foster dog, Eugene. He was a huge Rottweiler/shepherd mix and would act like he was doing you a favor when you walked him at the shelter. He was gentle, but indifferent to people, and appeared stiff in the back legs when he walked. He had been there for a while, as older large dogs are often passed over, but having two senior German shepherds of my own at the time, I thought he seemed like a good match. He was an easy foster. He got along with my dogs, was house-trained already, and fit well into our house. The cheerful, friendly dog who blossomed from the indifferent giant in the shelter demonstrates the beauty in fostering.

Eugene started running in the yard with my

EUGENE

dogs and seeking attention and affection from us. He began to bark at strangers outside our yard, and the true nature of his loving and loyal personality came out. Shelters do a great service, but they are not a home. What appeared as indifference in a busy kennel was just Eugene's way of surviving in a stressful environment.

Eugene was adopted by my dad a few weeks after I began fostering him. The stiff-walking dog, now known as Bo, jumped a fence to chase a squirrel his first week home and lives happily today as my dad's fiercest protector, loyal sidekick, and tolerant sibling of Missy, his canine sister.

Fostering brought me from a person who grew up with large dogs and had two senior German shepherds to now having a pit bull, two Chihuahuas, and a three-legged Pomeranian. Fostering made me fall in love with pit bulls and Chihuahuas. I was the person who thought little dogs were useless, yappy little critters who served no purpose. Now I never meet a Chihuahua I do not love. And if they're toothless and old, I'm in big trouble.

MAYA

Henry was one of fourteen puppies that I helped deliver for my foster dog, Miley. She lost five of her puppies the first day and I held each one and kissed them, letting them know that their short lives mattered. Henry grew with his surviving siblings, but a few weeks in he was not developing into the chunky butterball his siblings were. I would give him solo nursing time supplemented with formula, thinking he was not getting enough to eat. Nothing was changing. The shelter advised me to take him to the vet, where we spent a couple of weeks trying everything possible. I wanted to save him with every ounce of my being.

Maya was my first Chihuahua foster and my first foster failure. (*Foster failure* is the term we use in fostering when a foster never leaves and becomes our adopted pet, rather than someone else's. We joke that foster failing is not failing at all, that the universe brought us this particular dog to stay. While foster failures do occur for various reasons, most do go on to forever homes elsewhere.) The shelter never lacked for pit bulls or Chihuahuas, and I came to learn that they are the first and second most bred and most euthanized breeds in this country. Always one for the underdog, I wanted to help. Maya is a pistol and seven pounds of sass, diva, stubborn, mean, loving, loyal, and sweet. She is a conundrum of personality traits and I adore her for it. She keeps me on my toes, and I know she would stand up to the scariest enemy on my behalf. She started my slippery slope of Chihuahua love and I am so grateful that I broadened my narrow-minded view of little dogs.

HENRY

Unfortunately, Henry had a congenital liver defect and crossed the bridge as I cursed whoever did not spay his mom, whoever then surrendered her hugely pregnant, and whoever left me with the burden of loving him and losing him. I thought I could not bear loss like that. I swore I would not foster again. But with all things in life, we can grow and become stronger, or we can avoid love and joy in order to shelter ourselves from the risk. Henry reminded me that life is tough and too often unfair, but he showed me my own strength and resilience through his. He showed me that while his life was tragically short, it was full of love, and that made it all worth it. I not only survived losing Henry but also knew I could lose again and I would be okay.

I next agreed to take in a heartworm-positive puppy mill mom with mammary tumors. We quickly learned that Pacifica was in kidney failure and could not be treated for her host of health issues. It was determined that she would be a hospice foster. As heartbreaking as it was, a few days after finding this out, I officially adopted her, so that she truly had a family when she passed. We had a beautiful two months together filled with soft blankets, yummy treats, car rides, friends, and simple pleasures. She crossed the rainbow bridge in my arms, knowing unconditional love for the two months we had after her years of neglect and breeding. I could focus on those years, but I choose to relish the love of those two months instead.

Not all of my foster experiences have been so heart-wrenching; a lot of times they're just fun! Gemma is an adorable pit bull mix who came into the shelter and did just fine there. She is friendly, happy, and energetic. But I took her in to foster at a time when the shelter was over its capacity. She was house-trained, listened well, and was a pleasure to have in our home as a snuggling buddy. I shared her on social media and took her to events. My coworker ended up falling in love with her, and Gemma is now a bed-hogging, children-loving, and cherished member of their family. I find comfort in knowing that I was a part of her journey and confident that the perfect home was found for Gemma.

I think everyone should foster, and I make that known to the people in my life. You get to decide how much time you put into fostering by being selective about the animals you foster and how often you do it. The most common misconception I hear is that people feel they couldn't let a foster dog go because they'd be too attached. I understand—it has been a process for me too. From all the dogs and cats I've fostered, we have four dogs of our own, and that is my limit right now. Giving myself realistic boundaries has helped in this area because of course I love every dog I foster, but

Dogs are EVERYTHING that I strive to be. THEY LIVE IN THE PRESENT. THEY FORGIVE. You are the CENTER of their universe no matter what mistakes you have made. They are RESILIENT and LOVING, LOYAL and KIND.

PACIFICA

what kind of life would I be giving them by keeping them all? I would have a house full of too many animals for whom I could not provide adequate attention or financial resources–and I definitely could not continue fostering.

And for some fosters, you won't be too sad to them go! For me, puppies–who shred stuff, cry, poop everywhere, and need constant supervision–are the toughest. I love to kiss them, smell their puppy breath, snuggle them, and watch them sleep, but I'm happy to see them go to their energetic and patient families! Some fosters have a type. I started out wild and brave, fostering whoever needed it–large, small, calm, or fierce, we fostered them. But now I've definitely settled into who fits best into my home. It's super important not to burn out, both because you want to avoid having to return a foster and because you need harmony and peace in your own home.

Every single one of my fosters has made me a better human being. Dogs are everything that I strive to be. They live in the present. They forgive. You are the center of their universe no matter what mistakes you have made. They are resilient and loving, loyal and kind. They heal

wounds you did not know you had. They bask in the glow of the sun and do not see color, hatred, or prejudice. They find joy in simple pleasures and do not ponder age or illness.

The time that we can give them in foster care, no matter how short, can be magical. We have a role and responsibility as human beings to do something that has a positive impact on our world. I have found a passion in fostering. I know now that I can handle worms, wounds, medications, respiratory illnesses, disappointment, and heartbreak. I also know the pure joy, satisfaction, and purpose that comes from opening your heart and your home as a foster parent, and that far outweighs any of the negative. The look of a dog with the wind in his face on the car ride into foster care or the deep sleep you witness when she has a bed in a home is phenomenal. To say good-bye is harder at times than others, but seeing dogs go on to their forever home makes it all worthwhile. I have been rocked to my core with joy through this experience and found an inner strength that I was not even aware I had. Another dog will need me soon. Every foster dog who leaves takes a piece of my heart, but the next to come along soon fills the hole with his or her own special love.

They HEAL WOUNDS you did not know you had. They bask in the glow of the sun and do not see color, hatred, or prejudice. They find joy in simple pleasures and do not ponder age or illness.

Chili's Story AS TOLD BY HIS HUMAN, BRIT

hili came into my home obese, wounded from a dog attack, and nameless. I referred to him simply as Little Man, believing his future adoptive family deserved the honor of naming him. I volunteer with the Dachshund Rescue of North America (DRNA) and was serving as a foster mom at the time he was abandoned. Although I had adopted out many foster dachshunds before meeting Little Man, we had an instant connection, and something deep inside of me knew he was meant to be with no one else but me. The choice to adopt him, which the animal rescue world jokingly calls *foster failure*, didn't come easy. Only a few months before, my miniature pinscher, Pigeon, had been poisoned at our local dog park. To say the event was trauma-

tizing is an understatement. Her death left me with a hole in my heart, feeling lost and purposeless. Pigeon loved dachshunds, and I grew up with the breed, so volunteering with the DRNA felt like a healthy way to work through my pain and honor her at the same time. I never wanted to replace Pigeon, so I volunteered as a DRNA foster mom, saving the lives of Pigeon's friends without "replacing" her with another dog.

I secretly adopted my six-year-old foster dog, Chili (formerly Little Man), in August 2007. Still not emotionally ready to admit my connection with a dog other than Pigeon, I pretended no adopter was interested in him, which justified him living with me for months. Then the un-thinkable happened. Chili's disk ruptured in May

2008. He was paralyzed from the waist down. His future was bleak, considering the paralysis was paired with surgical complications. He needed me, and not just as a foster parent. He needed me to be his mom. Instantly everything changed. This ordeal made me admit that Chili was my dog, and I vowed to do whatever was necessary to save him. Despite the invasive back surgery, Chili remained paralyzed and we were told he would never walk again. But against all odds, after months of rehabilitation and sleeping together on my living room floor, he slowly regained movement in his hindquarters.

Less than a year after his debilitating surgery, Chili was up and walking (albeit unsteadily), allowing him to return to his favorite social group, the New York City Dachshund Meetup Group. Within the group he began competing in monthly competitions such as the weenie races, talent shows, and costume contests. His triumphant story gained national recognition, and he earned even more awards from organizations such as the ASPCA. Chili is an inspiration to all and has the medals to prove it. His most meaningful award is his grand-prize trophy for finishing in first place in the weenie races, senior division. Chili now has a display case full of ribbons, trophies, and other adornments, all earned after his "debilitating" back surgery.

Chili is a champion. An inspiration. A role model. A medical marvel. And the love of my life.

Chili is a CHAMPION.
An INSPIRATION.
A role model.
A medical MARVEL.
And the
LOVE of my life.

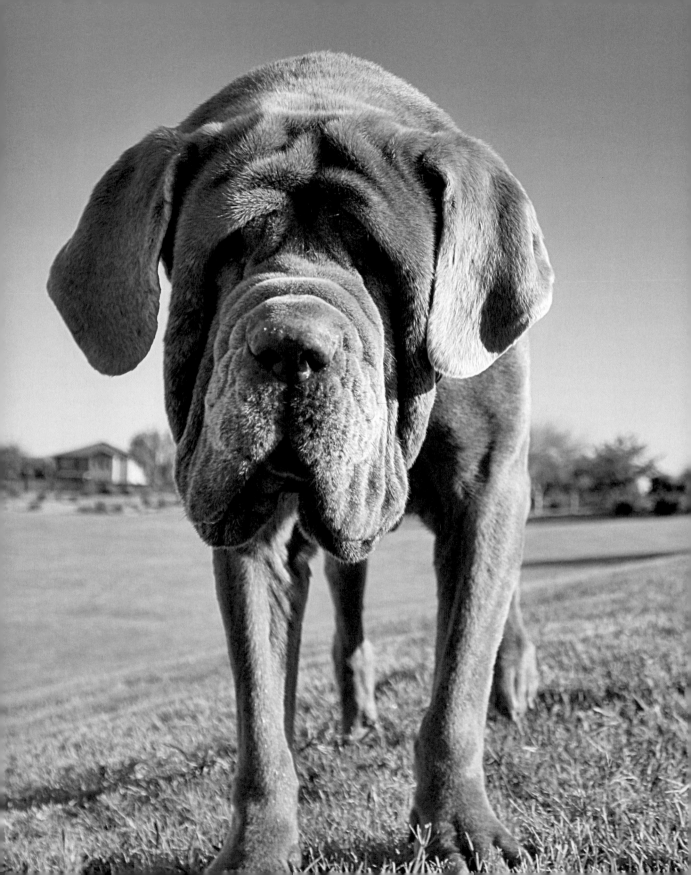

Barney's Story AS TOLD BY HIS HUMAN, CASSIE

Barney. For me, his name is his story. I say his name in my mind and I feel the full range of emotions: love, happiness, loss, peace, sadness, and back to love. Barney was not just my dog; he was a piece of my heart, living outside my body.

Barney was a senior Neapolitan mastiff in the Carson Animal Shelter in Gardena, California. He was a stray, picked up by animal control when he collapsed on a lady's front lawn and wouldn't get up.

On December 6, 2013, I picked Barney up to bring him home forever. Barney was my seventh adopted dog, but my first senior rescue. At the time, I had three dogs at home, relatively young ones, and I had no idea if Barney was going to be a good fit.

When we got home, we set Barney up with his own room, where he could rest and eat in peace. Barney spent most of his time sleeping, and I would sit with him, cleaning his wounds, grooming him, and talking to him. He was gradually introduced to his three furry siblings, and even thought for a moment about playing with his younger brother before he remembered that his body just couldn't take it. He was very weak, stumbling and falling often, but already he was starting to transform.

We soon integrated Barney with the other dogs. I was always surprised when he would tell the other dogs he'd had enough with one bark and they would all hit the floor. When Barney spoke, they listened. But he loved being around the other dogs, even just to lie near them. Occasionally, he would use my female mastiff's butt as a nice pillow, but only if he could lie in the sun at the same time.

At Carson Animal Shelter

In January, about six weeks after he came home, we went into the vet for a scheduled eye surgery. The vet started to examine Barney, and that's the moment I knew we were in trouble. He had lumps and bumps under his coat that had his doctors concerned. Surgery was canceled, and instead the vet just removed a couple of lumps for testing and we went home to wait. Barney was diagnosed with advanced cutaneous lymphoma.

Untreated, Barney would live, we estimated, for four to six weeks. It was so wrong and unfair. This beautiful, sweet dog who had probably lived most of his life as breeding stock, just to be thrown away when he was no longer useful, now was going to be killed by the cancer ravaging his skin and organs. I was heartbroken.

After a couple of days of feeling sorry for myself and angry with the world, Barney and I rallied. I decided to try chemotherapy, since I could give it to him in pill form at home. He had his first dose in mid-January and responded immediately to the chemo, with the lumps disappearing within a few days. In fact, Barney had his first trip to the dog park on the night of his first chemo treatment, and he had a blast. After that trip to the park, I realized that Barney was happy, with or without cancer. So I started a bucket list for him, to make sure I remembered to enjoy my time with him and help him really live in the time he had left.

We worked on Barney's bucket list until the end of May, and it was the best thing ever. His bucket list describes those months better than I can describe them now.

BARNEY'S BUCKET LIST

SMELL THE FOREST. Done, loved it. Wondered why we couldn't live there.

TAKE A NAP WITH MOM ON THE BED. Done, on Mother's Day.

EXPLORE THE DESERT. He was half blind and unsteady on his feet. Bad idea.

EAT DAIRY QUEEN SOFT SERVE. Said "no thank you." Also said no to really good vanilla ice cream. Not a big dairy fan.

MAKE NEW DOG FRIENDS. Done, at every opportunity. Favorites included Izzy, Oreo, Tygur, Manny the greyhound, an enormous Dane at the dog park, Brock, and Bear, and that cute little girl at the dog beach.

EAT SOMETHING SO YUMMY HE NEEDS A PLASTIC DROOL BIB. Done. Cheeseburgers, Barney balls, Five Guys fries, Polish sausage, Aimee's chicken jerky. Biggest mess ever—Barney dipping all of that face into a bowl full of protein shakes. But he loved them, so I cleaned the walls.

CHEW HIS OWN ELK ANTLER. Done. Preferred to nap holding the antler.

LEARN TO WEAR A DIAPER WITH DIGNITY. Done, to Grandma's house, to PetSmart, and to Beata's house. Didn't stop him from lifting his leg and peeing in the diaper on purpose.

HAVE A BARNEY PARTY. Every public outing turned into a Barney party. He was the belle of the ball at every dog event we attended. Kids loved to meet him, and he could not have been gentler.

LEARN TO TALK. He found his big Neo voice as he felt better, and there was nothing like it.

GO SWIMMING. Done, on purpose, without falling in the pool.

RIDE IN A CONVERTIBLE. Done, lying in the backseat, snoozing in the sunshine.

CLIMB A MOUNTAIN. Done, in the convertible. Barney experienced pure dog bliss up on that mountain, feeling the breeze and smelling the smells that must have come from miles.

WALK ON THE BEACH AND PUT HIS TOES IN THE OCEAN. One of our very best days, from start to finish. Barney was surrounded by countless dogs in all shapes and sizes on the dog beach, with people driving from all over L.A. to meet him. Dunkin' Donuts for breakfast and Five Guys for dinner. And some quiet time to stare out at the ocean and appreciate being alive.

On Wednesday June 4, 2014, Barney woke up happy and hungry. I fed him a big home-cooked breakfast and gave him lots of extra love and kisses before I left for the day. That afternoon Barney slipped away, napping in the sunlight. His final gift to me was to let go when he was ready, and to make his exit on his own terms. He left a tremendous hole in my heart and I still miss him. But I also know we did a really good job living for those few months, and that Barney was happy.

A lot of people think they can't adopt a senior because of the certain heartbreak that will come before you are ready. But I wouldn't trade the joy and love of those seven months for anything. Would I do it again? Yes! In fact I did do it again in November 2014, when I adopted a senior Neapolitan mastiff from a shelter in Corona, California, whom I named Penelope. You never know what you're going to get when you give your heart to a dog in need of rescue. In my experience, though, you always get more love than you could ever anticipate.

Adopting Simon

While visiting Los Angeles in the fall of 2014, I met Simon at the Carson Animal Care Center. Although I meet hundreds of shelter dogs on a regular basis and I want to bring them all home, I know that I cannot. But this time was different. I just couldn't leave this little tiny dog in this shelter. He was scruffy and toothless, visibly trembling and cowering, and nearly when I touched him it seemed to make it worse. Yet I also felt that he didn't want me to go.

The sight of Simon, confused and terrified, was actually not unusual for me—I see it often when visiting busy, overcrowded shelters. Not all dogs act this way, but many do. It's horribly heartbreaking and frustrating each and every time I meet a shelter dog like that, but that helpless feeling motivates me to keep advocating for shelter dogs.

At Carson Animal Shelter

As soon as I knew I couldn't leave the shelter without Simon in my arms, I took off to the

adoption desk. I didn't have a clue about the requirements for this shelter's adoption process, but I filled out an application and eagerly stood in line. I very clearly remember the adoption staff member saying, "You want the geriatric dog?" "Yes. Yes, I want the geriatric dog." The adoption process was quite simple, and I walked out the door with Simon an hour later. Simon's kennel card read: "I came to the shelter because my owner passed away." But beyond that sad detail, I had no idea about Simon's history or his state of health. I didn't even know if he would get along with Susie when they met.

Simon is by no means perfect, but in so many ways he is perfect for us. He is fearful of a lot of things, but he has come to trust our little family. He is as attached to me as if we have been together his entire life, and it is the greatest feeling in the world. We lead very busy lives and Simon takes it all in stride. He will happily hop into his little travel bag, or if he has to stay home he will curl up and snuggle next to "his Suthie," as we imagine him calling her (now, after a needed dental treatment, he's completely toothless) until we return. He is needy for human affection, attention, and love, and it's the best kind of needy there is.

I don't think about the time we missed out on with Simon. I just don't see it that way. To me, that wasn't our time. I think of how lucky we are to have found Simon now. Of course we hope for as much time as possible with him, but for however long we have, caring for Simon will most certainly be better than if we never had the chance at all.

I had pee pee accident in the bed last night.

I told him he should have peed before he came to bed!

susie says:

My parents are lucky that I'm so chill. Bringing home Simon was pretty uneventful for me. My life didn't really change at all, except for more snuggling. All that boy wants to do is snuggle with me! So I let him. He once told me he hates being alone. It's his number one fear in life. So when the humans leave the house, he's my Velcro dog and doesn't leave my side. I tell him he needs to relax and that the humans always come back, but he never listens; he sticks by me until they come home again. But it's cool, I know he might not have had a good life before coming to our family. And I know he respects me, and that counts for a lot. I don't always tell him, but he sure is a good brother.

♥ NY

When I first moved to Los Angeles, I was looking for something to be involved with, and I saw a billboard for No-Kill Los Angeles (NKLA), the palatial and amazing no-kill shelter newly opened by Best Friends Animal Society. It seemed like fun to walk dogs and play with them. The more I volunteered, the more I learned about animal rescue and the dire need for community involvement. I knew, in the back of my mind, that there was a big unfulfilled need for volunteers at the city shelters, which are most definitely not no-kill, but I always thought they were for people made of sterner stuff than I. I didn't think I could face volunteering in a building where animals were killed. I didn't think I had the emotional fortitude to deal with it if a dog I had come to love was euthanized.

However, when the Los Angeles city shelter put out a plea to foster a dog for just four days over the Fourth of July weekend, I couldn't refuse. I knew I could do that. So I took in two foster dogs for the long weekend, got them adopted very quickly, and then they had me hooked! Once I saw for myself the immense need for volunteers and resources at a city shelter, I couldn't turn a blind eye any longer. I knew that, as a member of this community and a dog lover, this was my problem too. And if I didn't have the emotional strength, then I'd better get it fast, because those dogs needed help and I could give it.

Since then, I've learned a lot about the city shelters and I've found that I value the time I spend there more than anything I've ever done before. To me, a city shelter is like a triage center for saving dogs. We can't say sorry and refuse to take a dog because we don't have enough foster parents or dog walkers or blankets or kennel space. No matter the reason, we will take in any dog. Maybe their family fell on hard times and, even though they loved them, couldn't afford to care for them anymore. Maybe their owners got sick or died.

Maybe their owners were irresponsible and never went looking for them when they got lost. Maybe their owners were heartless and traded them in for a newer dog or just grew tired of caring for them. Maybe their owners were just plain cruel. Whatever the case, these dogs were dealt bad cards at some point and they wound up in the shelter.

Our animal control officers love and care for our animals. They treat them with dignity and kindness. Our volunteers make do with very few resources and often pay for things other groups take for granted, like leashes and blankets, out of their own pockets. Our shelter director works tirelessly, networking each and every dog to as many rescues as will listen and have space. Nobody here wants to see a dog go without a walk or a blanket or even a simple "good dog." Nobody wants to see an animal euthanized here. It absolutely steals a piece of my soul when an animal is killed at our shelter.

What destroys me most is that I know if we had more people coming to adopt, more people who thought that shelter dogs were great dogs and not broken or defective, we could save them. That's the real secret of the city shelters. Our dogs are just dogs. They are wonderful. There is really only one difference between the dogs sitting in the shelter and the one sitting on your couch. It's not size, or shape, or color, or breed. It's not the amount of love they have to give; it's not their personalities or the way they look; it's not anything they did. It's just pure luck that some dogs get great homes the first time around. They luck out and get families who take care of them their entire lives, and they know nothing but love.

But our dogs are not the sum of these environments. They are so much more. Their lives matter to us and we try to deserve their love. We see their worth and their beauty and we continue to hope and work for the day that everyone else will too.

Eva's Story
As Told by Her Human, Jenny

The day we brought Eva home she weighed about 68 pounds and we had to carry her up our four front steps. We've had her for thirteen months now and she has grown to 100 pounds of joy in our lives.

Eva was this sad, pathetic, broken, old Cane Corso girl. The City of Elderly Love animal rescue in Philadelphia saved her from a cruelty court case. Her back legs barely worked and they thought she might have cancer because she was

skin and bones and wasn't gaining weight at the shelter. They wanted her to live out the rest of her life with love and dignity in the comfort of someone's home. When I saw her story, my heart stopped. Before my brain could catch up or my fingers could text my fiancé, Danny, I commented on her post and said I would take her!

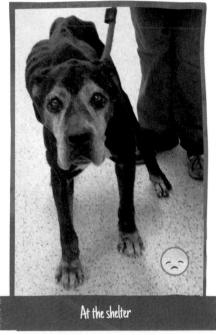

At the shelter

A couple days later, we headed to the Pennsylvania SPCA shelter where she was living. They brought this sweet, hunched, skinny girl out of her crate to see us. She hobbled up to me and put her head between my legs as if she knew. Eva could barely walk on the shelter floor, and her whole spine curved to the left in a *C* formation. She slowly made her way out with us to a grassy area, where she just stood and looked up at me with doe eyes. I fell HARD. I sat on the grass with her and just hugged her. As her vet was telling Danny and me about her and how she wasn't gaining weight and how she could have cancer and how we would

probably have her for only a couple of months, I was whispering into Eva's ear that I would love her for the rest of her life and always take care of her. We came back two days later to bring her home!

Eva has blossomed like a spring flower and evolved like a beautiful butterfly. She is feisty like the dog she probably used to be before we knew her! Slowly but surely we began to see her reach new milestones. Her first time standing up on her own and walking without her wheeled cart. Her first time walking on her own to the dog store several blocks away. Her first time romping and running on a beach, dashing into the ocean, fearless.

Aside from being sensitive, Eva is such a clown too. She makes us laugh multiple times daily with her antics, whether she's running like a crazy girl to follow us, doing her pathetically cute whine with her doe eyes, jumping on top of us on the couch like a puppy, or getting jealous even hearing us say Gráinne's (Eva's dog sister) name! She seems to love to make us smile.

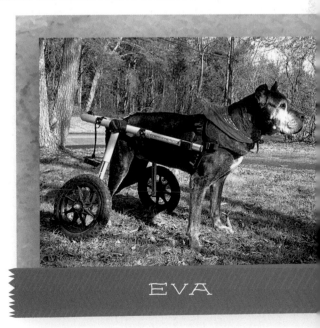

EVA

GRÁINNE

Gráinne had been in a kill shelter down in West Virginia. After the rescue picked her for us, she was put on the "freedom bus," a transport truck, and we picked her up in New Jersey off the back of it. Sweet little soulful girl she is, we named her Gráinne, which is Irish for GRACE.

We have such love for this creature who has graced our lives for only a short time that we feel like we raised her from a puppy! And oh, man, we wish we could have seen what she was like as a puppy. She ain't no hospice anything now, that's for sure. Eva has let us all know that she is here to stay! She greets every morning with a smile and makes us appreciate what we have each day. She won't let her aches and pains slow her down and she still wants to be included in everything we do! And we will do everything in our power to keep her feeling that way.

I would adopt a senior dog again in a heartbeat. We would never have guessed just how attached it's possible to get. They rely on you and you create a space of safety, comfort, and care for them such that the amount of time doesn't seem to matter. Even if it is for just a short period of time, the bond you form is like nothing else. We are grateful!

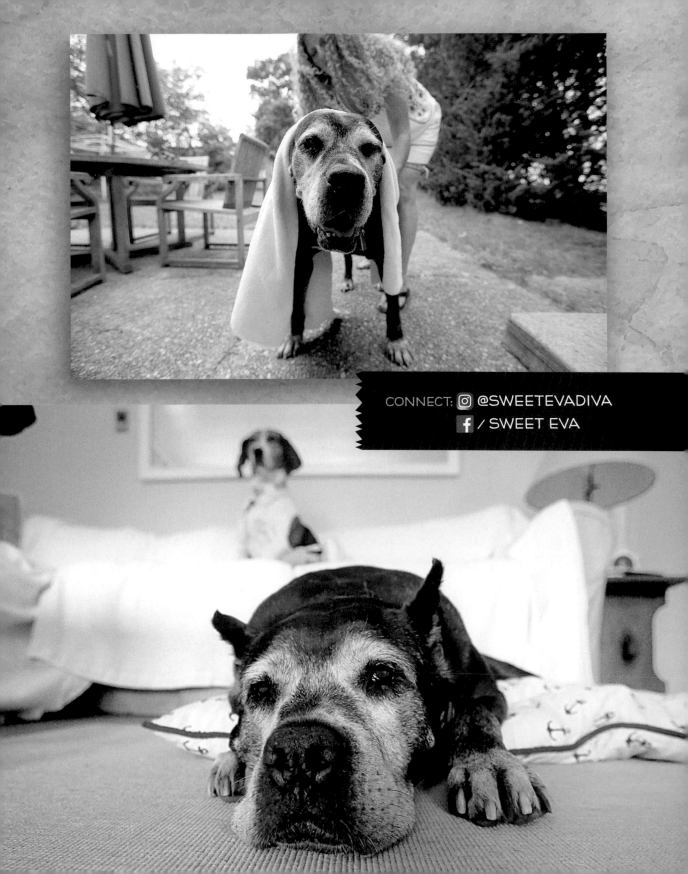

Susie Says:

If you think senior dogs lack personality, spunk, and va-va-voom—think again! Thirteen-year-old Chloe Kardoggian has carved out fame for herself by living life to the fullest (in a three-pound body!) and posting about her daily activities and adventures on social media. Chloe has quite the following because, despite being a senior dog, she is anything but boring!

A Day in the Life of
CHLOE KARDOGGIAN

7 A.M. **WAKE UP** to receive snuggles and a treat from my human. she used to hide a pill in those morning treats but she switched what she gives me and I think she stopped hiding them. or wait . . . am i not finding them? oh dear . . . must investigate.

8 A.M. human leaves for work. she must keep me in the luxurious lifestyle i demand! Just a few more minutes of sleep before my first Instagram pic of the day. i can't have any bags under my eyes!

9 A.M. wake up, groom myself, **HYDRATE WITH A THIMBLE**
 of water. all the celebs talk about how important it is to drink lots of water, and when you're 3 pounds, that's the equivalent of a cup!

9:15 A.M. some light stretching and yoga to keep myself toned and limber. favorite pose? **DOWNWARD DOG**, natch!

10:30 A.M. morning **NAPTIME**— yoga wears me out!

11:30 A.M. wake up and check email in case any big **MOVIE OFFERS** come my way (paws crossed). keep in touch with my fans and furriends on Instagram and Facebook. help get out the word for any furriends who need homes and can't find them.

chloekardoggian
Witness Protection
Following

2,967 likes

chloekardoggian Chloe? Sorry, Monday... Never heard of her... I'm Zoe, not Chloe 😊 #incognito
view all 105 comments
stylepup Pretty in Pink 💗
annaeshelman_shadowdoxie 😍😍😍😍 oh hello Zoe💜💜💜💜
bigkhloe3 😍😍😍
toritilllla @trinidadbran
ilariatorcini @son.es
ikesugianto Witness protection 😂😂😂😂
zoebirdk @laels
patches_theaussie @chloekardoggian adorable😍°o
mpintobeans88 @weenzybeans meet Chloe
barbaraolachea @grecia.olachea

Add a comment...

12:00 P.M.
¼ cup kibble

12:30 P.M.
early afternoon nap

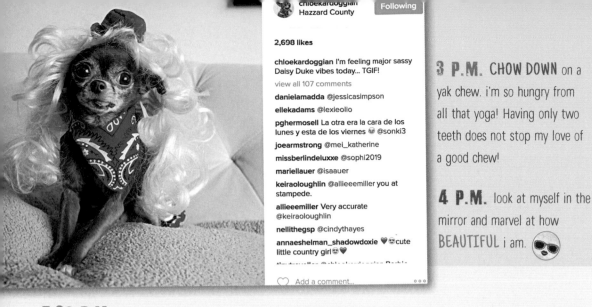

3 P.M. CHOW DOWN on a yak chew. i'm so hungry from all that yoga! Having only two teeth does not stop my love of a good chew!

4 P.M. look at myself in the mirror and marvel at how BEAUTIFUL i am. 😎

5:30 P.M. human comes home and requires major snuggling and kissing. her arms always seem to need a clean-up so i spend as much time as she'll allow licking them. eventually she makes me stop—so ungrateful. people would pay a lot of money for my services! Then I'm sure to have her help me post my evening Instagram photo. My public demands to see me at least twice a day and i must give them what they want! MEEEEEE! 😊

6:30 P.M. ¼ cup kibble and another one of those treats like i get in the morning. i think there may be a pill in there but they're so yummy i am ignoring it!

7 P.M. WATCH _JEOPARDY!_ with my human, then take our nightly walk around the building. (that's like 2 miles on my 4-inch legs!)

9 P.M. SNUGGLING and catching up with my human about our busy days. she is required to tell me she loves me at least 20 times during this conversation.

9:30 P.M. BEDTIME! tomorrow we do it all again!

Timba's Story

As Told by Her Humans, Phyllis and Walter

I thought we were going to lose Timba, but this story has a happy ending, thank goodness.

Our sweet girl was failing. She began falling down and became incontinent. When we tried to help her get up, she would whimper, and then all of a sudden, she'd have a terrible seizure. Walter and I were beside ourselves because she had been on seizure medication since last summer, when she had the first seizure we had witnessed. After the seizure, things only seemed to get worse. She wandered around the backyard as if she was lost. She was unable to go from standing to lying down without falling, painfully and with a thud. She couldn't stand without one of us lifting her, and she couldn't use her doggy door because her aim was off and she didn't seem to have the strength to push it open. She would pee while lying on the kitchen floor and get very upset each time we tried to help her up to go outside.

I called our vet, who happened to be out of town for the weekend, and honestly, if she had been here, we would have asked her to help Timba cross over the rainbow bridge that day. We were terrified of allowing her to suffer, and she has always been such an independent and dignified soul that we couldn't bear the thought of prolonging any discomfort.

Our plan was to make the dreaded appointment for Monday morning when our vet had returned. Walter stayed home from work and even prepared her final resting place with love in our backyard next to where our MuShu was laid to rest two years ago. When we came downstairs on Monday morning, prepared to clean up the puddles and lift her to help her outside, the kitchen floor was dry. Our first thought was that she had passed in the night, and we approached her gingerly. She sprang up as if nothing had ever happened and ran through her doggy door to take care of business as usual in her favorite spot in the yard.

I watched incredulously as she bounded back inside and stood looking up as if to say, "Where is my chicken stuffed with pills?" We almost didn't dare to hope that this could be happening. We had spent the weekend in tears, preparing for the worst. We spent two entire days without leaving our kitchen except to grab a couple of hours of sleep, much of the time sitting beside her on the floor offering her water or chicken or just scratching her ears and loving her up. And then, on Monday morning we awoke to an apparent miracle.

I went to see the vet to talk about what we should do. When I told her what had happened, she explained that seizures are very strange with old dogs. There can be a pre-seizure period, during which the dog acts strange (disoriented, off balance, clumsy), as well as a post-seizure period, from which they sometimes recover but often do not. Given Timba's age (she will be fifteen!) our vet was surprised to hear how well she had bounced back. She prescribed a bit more medication and "lots of her favorite treats."

We are so grateful to say that our sweet girl continues to astonish us with her energy, appetite, and graceful use of her doggy door. She loves cuddles, maybe more than ever before–or that could just be my imagination and my continuing need to show her how much she is loved.

LESSONS WE HAVE LEARNED FROM THE BEAUTIFUL TIMBA

- Always walk with dignity . . . with a prance in your step, a twinkle in your eye, and a smile on your face.

- When you look like a wolf, you can act like a lamb.

- Smaller dogs are to be ignored, especially when they bark in your face or make a grab for your treats.

- Focus on your job and leave the squirrels, chipmunks, and birds in peace to do theirs.

- Provide an example of maturity for the younger members of the pack. When a treat is dropped between you, take a step back and let them have it. No treat is worth fighting for, and you will be rewarded with extras for your good behavior.

- Howl when you are happy so that the world can hear your voice.

- Only those who deserve kisses get kisses. You can't go around kissing everybody.

- You most certainly can teach an old dog new tricks, and life expectancy ranges are for sissies.

- Never give up. Rest when you don't feel well, then resume normal activities as soon as you feel better. Age is only a number.

In Sickness and in Health

Dogs, like humans, all have their own standard of health. It's a common misconception people have that all old dogs are walking vet bills. When owning a pet of any age, you have to be financially prepared to care for them, and all pets should be under the supervision of a vet on a regular basis. But senior dogs don't always represent guaranteed health problems. Each individual dog is different, and they shouldn't be dismissed just because of age.

Susie has had her share of panicked trips to the doctor, although mostly they've turned out to be very minor issues. (I joke that Susie likes to fake things just to see our stress and test how much we love her!) However, she did once have a serious incident that resulted in a two-night stay in the animal hospital. One afternoon we noticed that Susie was coughing excessively and acting strange. Because she was fifteen years old, we rushed her to the emergency room, not knowing what this could mean. At the hospital, the vet staff discovered that Susie's lungs had filled up with fluid and she was immediately whisked away to intensive care. Forty-eight hours later, Susie pulled through and was given the okay to go home. It was at this time that she was diagnosed with "heart failure." We were devastated and assumed the worst: Her end was right around the corner. So we took her home with a prescription for heart medication that she would be on for the rest of her life. But rather than getting worse, little Susie has done great! She's healthier and heartier than before she stayed at the hospital. And adding the medication to Susie's daily routine was actually less of a big deal than expected. Susie is like the Little Engine That Could . . . she keeps on chugging.

When we brought Simon home from the shelter, we had little history on him and no vet records. But he got a clean bill of health at the first checkup we took him for! Simon has a strong heart and is in great shape. When we adopted him, he only had one front tooth left, and it was rotting. As recommended by his vet, and since his blood-work results were perfect, we eventually had his last tooth extracted. Simon is now completely toothless and is none the wiser. He eats well (ground-up kibble and other soft bites) and lives a very happy toothless life. It's also the reason that his adorable little tongue is hanging out all the time! 😛

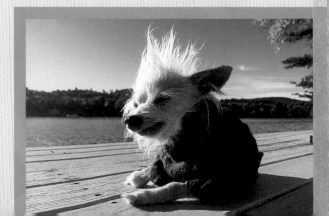

Susie's Sixteenth Birthday!

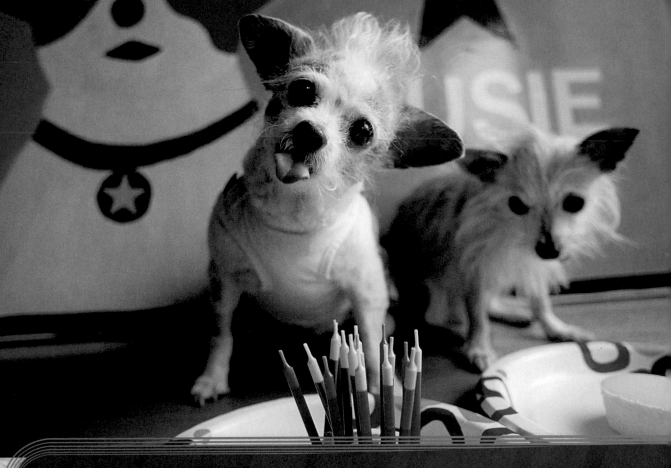

SUSie Says:

Happy sixteenth birthday to me!!! I've made it another year. I'm so lucky. I'm so loved. I'm so . . . old. And I couldn't ask for anything more! I never thought I would have so much to show for my late stage of life. To date, I've seen over 500 senior dogs find homes through SSD in its two short years of existence, dogs who most people thought would never be given a chance. I've traveled much and gained some popularity in my senior years, but nothing makes me happier and inspires me more than the many humans who have selflessly adopted an old dog. This is the best birthday wish that an old gal like me could ever ask for. Now let's eat cake!

While SSD posts many happy stories of senior dogs who instantly settle into their new forever homes, for some people, the road's a little bumpier. It's important to remember that some dogs are just better at rolling with the punches and handling change, while others take some time to warm up. If your first day with a new adopted pet isn't all snuggles and biscuits, don't lose hope! With patience, kindness, and the help of experienced dog lovers, you'll soon have a tight and joyful bond with your rescued senior.

Kahlua's Story AS TOLD BY HER HUMAN, SUZIE

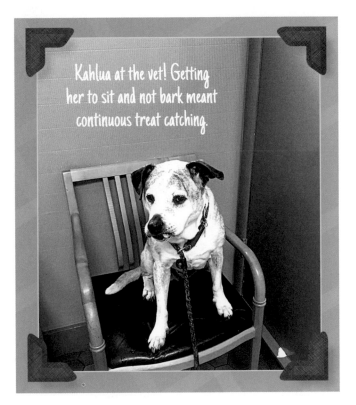

Kahlua at the vet! Getting her to sit and not bark meant continuous treat catching.

I was really overwhelmed the first week I brought Kahlua home, through absolutely no fault of her own. In hindsight, I didn't really ask many questions before adopting her, because I really had no idea which questions to ask. I also didn't know what was important to me until after I got her home. I don't like to dwell on it too much, though, because I think if I had gotten those answers it would have discouraged me from getting her, and she's been the sweetest, sassiest pup otherwise. None of us is perfect, and in the grand scheme of things, her quirks are just minor inconveniences and not deal breakers.

I immediately scheduled a vet checkup after picking her up from Family Dog Rescue in San Francisco. Rookie mistake number one! It did not go well. She is not a fan of the vet, the vet was a little scared of her, and I had no idea what to do. We left shortly after with no checkup performed.

Once I brought her home, though, it was a different story. She immediately started following me into every room I went to, waiting outside the bathroom for me, and being protective. It's so funny because when Kahlua first meets people who come into our home, she takes some time to warm up and greets almost everyone with a harmless bark. She is cautious, a little distrustful, and reserved. But with me, there was none of that. She took to me immediately. It's almost like she knew before I did that I could never

have let her go. She's very protective of me and allows me to get away with things that others can't. Like shoving my face into her adorable flaps and kissing her all over.

I was so worried about whether I was doing the right thing and whether I really could be responsible enough for a dog. All of a sudden, waking up every morning to take her out was daunting. She barked (and still does) at every single person who walks into our apartment. She barks at dogs we walk by. Because we live in San Francisco, an extremely dog-friendly city, there are dog parks galore. Unfortunately, Kahlua would start off playing nicely and then start barking and lunging, thus making other owners uncomfortable. She's territorial with our apartment, and none of my friends' dogs can come over.

After eight months of having her, I got a dog trainer, which has been completely eye-opening. A lot of my friends and family were uncertain because, well, Kahlua is ten years old. Can't train an old dog, right? Wrong! The trainer was actually primarily for me to learn how to interact with and lead Kahlua, as it was my first experience. And what the trainer immediately saw was that Kahlua is very smart and loyal (I already knew this!) and desperately wanted to please me. The hound in her, plus old age, just added some stubbornness. We immediately set some boundaries for Kahlua: no couch, no kitchen, no beds, unless invited. These have helped so much. She has calmed down and doesn't bark as often at guests. Granted, we know that the second we leave the apartment, she jumps on the couch, but when she hears us come home, she immediately jumps off again. Clever gal.

We also found that what I and other dog owners mistook as aggression at the dog park was really just Kahlua being a sassy "park police officer." She was herding the other dogs, telling them to slow down, and trying to correct the younger dogs. She's that grandmother who knows best and wants everyone to follow her rules (for example, you're not allowed in the park until she sniffs your butt first!). So now we're working on managing her bossy tendencies.

Kahlua has gotten so much more comfortable, calm, and sweet since being with us. She's so much more affectionate and cuddly than she was initially, and her personality is just so big! She makes these weird dinosaur noises when you scratch her belly and is just so sassy sometimes, it's incredible. Her quirks make it so much fun. I love when she leans into my hand as I'm scratching her.

I'm surprised at how well Kahlua has been able to integrate into my lifestyle. I'm a late-twenties gal, living in the city and working full-time with a fairly active social schedule. Getting an older dog has really been the only way I could even consider having any dog. I have a couple of friends who have recently rescued puppies, and their stories of pups needing constant exercise, ripping up their carpet, or eating their $140 slippers make me so relieved in my decision to get a senior dog. I get happy all over again that I chose a more mature gal who doesn't need that training and is past the destructive phase. And not needing to spend hours exercising her has allowed me to maintain my lifestyle and hobbies (like thinking about going to the gym).

I'll never say that owning a dog is easy, but Kahlua has made being a first-time dog owner SO much less stressful than it could have been. Sure, she's got some habits that might not be ideal, but they're in no way destructive or unmanageable. She had basic training and lounges freely in the apartment when we're gone with no worries of her ripping anything up; she's potty trained, she listens, and none of it was my doing!

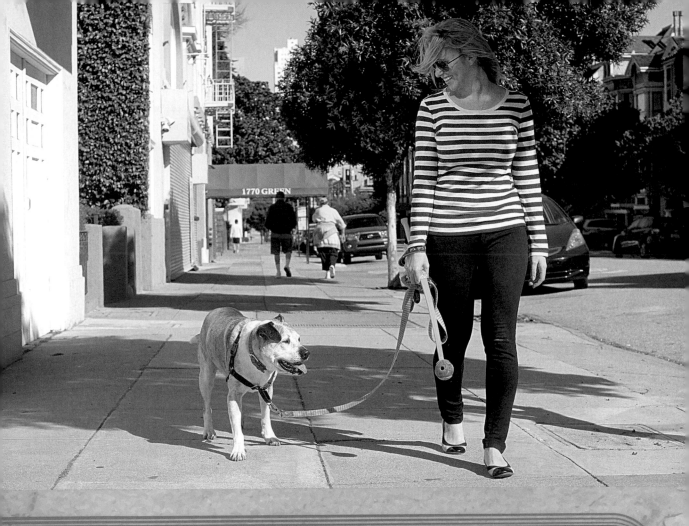

susie tip!

Hiring the right trainer can make all the difference for you and your pet. It is an investment that goes beyond a well-behaved dog—you are working to build a trusting and loving relationship between you and your canine companion. You might not always hit it off with the first trainer you meet, but it is worth the effort to research who might be the right trainer for you. A good place to start your search may be through your local reputable rescue. Some rescues work with trainers to help their incoming dogs become more confident and to help them make the transition more easily into their future adoptive homes. However you find a trainer, commit yourself to the training process and let patience prevail. Trust me, your dog will thank you for it!

Cleo's Story
As Told by Her Human, Pamela

I never wanted a dog because I thought they were sloppy–dirty, drooling, paws on the sidewalk. I had a friend who liked pit bulls and I thought she was strange for that. Why would anyone get a violent dog? It was my daughters who led me to change. All my beliefs shifted when I started reading about senior dogs, shelter dogs, and adoption. It's hard for me to believe that I thought pit bulls were strange-looking and for violent people! I now think pit faces are absolutely adorable.

Our first dog was Jasmine, "a Coton de Tuléar." Growing up, my daughter Valerie was on a playdate when she went into a pet store on the Upper East Side. A lot of my friends got their pets from pet stores or breeders. I looked up policies on the ASPCA website and I went to the stores with a list of things they should be doing. It turned out that the cages and other care were as specified on the ASPCA website, so I really could not complain. It was then we spotted adorable little Jasmine. We all fell in love with her.

Never having been a dog owner, I made a lot of mistakes. I found a walker who was also a trainer. But Jasmine never really got trained and she developed some aggression toward other dogs, particularly packs. I then realized the trainer was not really doing what he had

promised. And now Jasmine was not yet housebroken and she had developed bad habits, including separation anxiety. Finally I met a fabulous trainer who told me I had to be the pack leader and taught me how to assume the role. We had Jasmine for four years before Valerie began asking for another dog. Valerie found a breeder with bich-poos and we went to a farm in New Jersey to pick up Major. They are fantastic companions and Jasmine quickly got over her painful separation anxiety.

We had gone to a shelter before we got Major, but I don't think any of us had an open mind. I did not realize that all kinds of dogs could end up in a shelter. I thought only dogs with problems ended up in shelters. When I would walk our two little dogs in the park and meet people with adopted shelter dogs, I did not believe it was for me. I thought those people knew more about dogs and that shelter dogs were for advanced dog people; people who didn't know much about dogs should buy them from a pet store or a breeder because the dogs would have fewer problems. I never even thought about senior dogs for a second. I assumed everyone would want to start with a puppy.

It was my daughter Sabrina who introduced me to Susie's Senior Dogs on Facebook. I

started following online and learning about senior dogs, shelter dogs, and adoption. I started reading a lot of books; I read about dog communication and calming signals, and it has changed my relationship with my dogs. I now think I am good with dogs. I love them and I think I am blessed to have a little bit of understanding of them and what wonderful creatures they are. I am also a more confident dog person.

Cleo caught my eye because of her sweet face but also her description on the SSD site. There were so many appealing things about her: I no longer felt shelter dogs were difficult or that pit bulls were always violent. I was learning that most dogs want to be social and part of a family. But when I read in her bio that Cleo was "first and foremost a dog," I understood that she wanted to go to her home and just be with a family. So now she can be "first and foremost a dog" and be loved and appreciated for just that.

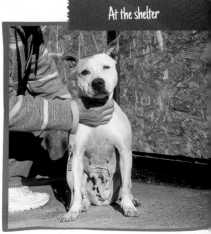

At the shelter

MAJOR

When we brought her home, she was so sweet and scared. No real "freedom ride" smile. She had a lot of fear.

All was peaceful except for a toy fight with Major, where she bared her teeth. It was scary to see those big teeth and I got worried that I had made a big mistake. We had toys out all the time because Major and Jasmine were used to playing with each other.

One trainer I had talked a lot about human error. Leaving the toys out I would consider human error. I had to adjust to Cleo's behavior. It was my responsibility to remove the toys and create a safer environment for all the dogs.

After the toy incident, Cleo seemed to lie alone in the sun a lot. She seemed a bit isolated. I thought she needed a friend her own size. I thought she would never come out of her shell with the little dogs. She really was easy and not demanding and I thought that maybe I could give a home to another senior.

Within weeks of Cleo's adoption and my idea that she needed a pal her own size, Fenton appeared on SSD. In his write-up, a sentence about him losing his family and needing a new one really got to me: "Sadly, he is an orphan now and must find a new human and a new place to belong to."

I got myself and the three dogs up and out for a meet and greet. The New York City Animal Care Center staff could not have been nicer. We adopted Fenton and things couldn't have been better on the way home–all dogs were sniffing and walking peacefully. However, when we got home, Fenton started running around with a crazed look in his eye. Then the two pit bulls went at it. The territorial part came out inside the house. "What have I done?" I thought. They liked each other outside and that was perfect, but inside things were different. We should have started with separation right away.

I recalled that the staff at ACC had said to keep the dogs apart as much as possible for the first two weeks. We used different rooms, crates–all kinds of ways of separating, with slow and controlled meeting times. I called the trainer, who taught me techniques and also built up my confidence. He was very careful and cautious and did everything very slowly. In fact, he taught me to slow things down with the dogs. When they get anxious, I breathe, I slow down–and it helps! I learned more about their body language and their communication. Yelling and pointing fingers is not calming for dogs.

I feel that it took my having four dogs to transform into a dog person. I feel blessed to have some insight into their wonderful world. Now when I tell my friends that I have become a dog person, they say, "Isn't it wonderful?" Yes, it really is.

FENTON

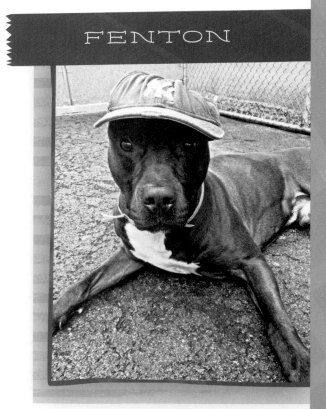

Bourquey's Story
As Told by His Human, Christy

Prior to adopting Bourquey, I didn't think much about shelter dogs. With my family's allergy constraints, I didn't believe that there would be any dogs to be found in a shelter that would fit our specific needs.

Dog talk has been a part of my relationship with my husband, Chris, since the very beginning. He put up with my antics and endured many dog-obsessed behaviors. As we prepared to buy our first home, the conversation immediately turned to dogs. Chris asked that we wait a couple of months after moving to settle into

Petey, now Bourquey, first day in foster care

the house before getting a dog. We moved in on a Saturday, and by Monday morning I had sent Chris fourteen listings from Petfinder. Our deal was out the window.

Apart from those early Petfinder inquiries, I am disappointed to say that the rest of my research centered around local breeders. Since my childhood dog, Abby, my parents had both acquired serious allergies to pet dander and had a difficult time being in the same house as a regular mixed-breed dog. I had learned about Maltese from one of the strangers I stopped on the street for dog talk and knew that they had hair instead of fur, didn't shed, and were widely believed to be hypoallergenic. Due to my

misconceptions about shelters and my timeline (immediately!), I didn't think I could find such a dog in a shelter.

We went to visit a backyard breeder a week after moving into our house and both fell in love with a tiny, eleven-week-old, apricot female Maltese who jumped into our laps as soon as we sat down on the cool concrete garage floor.

Maxie quickly became the center of our lives. Embarrassingly, we spoke of her with the love and reverence most people save for talking about their children. It was with much consideration that we decided to bring another dog into our family.

Fortunately, nearly five years after getting Maxie and many, many hours of dog research later, we now understand that our misconceptions about shelter animals were just that–misconceptions. Our story of adopting all began with my friend Micah. Micah and her husband, Steve, opened their door to foster a shelter dog, an 80-pound senior black lab named Raider. It was easy to watch them fall in love with Raider, even from across the country, and quickly enough they became foster failures and adopted him. Whenever Micah posted a Raider picture to Instagram, she would tag it with #seniorpup.

One day I clicked on #seniorpup and found Susie's Senior Dogs for the first time. I immediately started to follow SSD's every post on Instagram, yearning to help dogs that were waiting for their chance at a better life in Miami, Los Angeles, Texas, Kentucky. My heart broke with each new posting–those eyes! this poor dog's owner passed away! how could *he* be overlooked?!–and soared with every successful adoption. I augmented my growing understanding of shelter dogs (they are rarely bad or difficult dogs, but just regular dogs who've fallen on hard times) and learned more about the economics of the pet industry (demand, designer

breeds, overpopulation). I had always known that puppy mills were bad, but I learned so much more about the whole pet industry ecosystem.

And then Petey the Perfect Poodle was posted for the first time. Petey looked so happy, so loving, with such a personality, I couldn't get enough of him. I was positive he would be adopted from his shelter, Social Tees Animal Rescue NYC, immediately—I had such a strong affinity for him I was sure that other people did too, and there was always someone posting comments about wanting to adopt him. He even had his own Instagram account, @PeteythePoodle, and I found myself returning to the photos over and over and over again to revisit little Petey. But time kept passing and still no one had adopted him. I had to do something.

I sat down one evening, nervous to have the conversation with Chris. We had just ruled out getting another dog: It wasn't the right time, we'd just moved for the second time in five years, to Connecticut, and we wanted to give Maxie time to adjust to her new home—all of the usual excuses. "I want to put in an application to adopt Petey." I justified it pretty well: I knew he had received a number of inquiries, so there would be at least three people ahead of us in line for him; they might not even get to our application; but I just couldn't live with myself if we didn't at least try.

Chris agreed, and I immediately filled out the Social Tees adoption application. Those other inquiries didn't materialize, and soon we were approved to adopt little Petey. But first we had to see whether he and Maxie would get along. We did hours of research about introducing new dogs to existing dogs, and we were very concerned with stepping on Maxie's toes. We learned that we were to introduce them out-side, but to let them work out any dominance

MAXIE

issues between themselves. So on Maxie's fifth birthday, Chris, Maxie, and I drove into New York City to meet Petey in Bryant Park.

And . . . it was a disaster.

Petey was super excited and kept jumping on and mounting Maxie. To be fair, he had been neutered less than a month before, and he wasn't being vicious or aggressive. All of his actions were out of interest and enthusiasm. We walked around the block a few times, tried sitting in the park and in front of the library, but Petey was worked up and wasn't going to calm down that afternoon. We decided that it was worth the risk and that we owed it to Petey to try.

We picked Petey up the following day. We came alone, deciding that it was best to wait until we were home to bring Maxie into the equation. When we got home, Chris ran inside and brought Maxie out front to meet Petey in the yard. We spent an hour outside with them running and sniffing and marking, getting acquainted and comfortable, before we opened the door and decided to take a chance going inside.

Chris and I noticed a change in Maxie once Petey was inside. We think she realized that he was going to be with us permanently and wasn't just a passing neighbor dog out on a walk. She withdrew from us a bit and committed herself to

a pouty disposition as Petey showed no signs of leaving. I wondered whether we would ever see Maxie smile again, but Chris was significantly more affected by her sadness, to the point of being pretty sad himself. I also noticed that Chris wasn't calling Petey by name. "I like his name," Chris told me. "But it makes him feel like someone else's dog."

"What if we change his name to something we choose? Do you think that would make a difference?" I asked. Maybe, he said. So while he was in the shower that evening, I started to brainstorm ideas for a new name. I ran a bunch by him, but nothing seemed to click, and Chris still seemed worried about this new addition to our home.

We're both originally from Pittsburgh, and Maxie is actually short for Maxime Talbot. We brought Maxie home five months after the Penguins won the Stanley Cup in 2009, in which Talbot scored the winning goal in the seventh game. I thought about the Pittsburgh hockey commentator and former Penguin, Phil Bourque–or Bourquey (pronounced *borkey*), as his broadcast partner (and most of the city) often called him. "What about naming him Bourquey?" I asked. Chris paused for a moment, the first suggestion I had made that he really considered, and agreed. Bourquey felt comfortable; Bourquey felt a little bit like home.

"Is your name Bourquey?" Chris asked the dog. His tail wagged. It was decided.

Renaming Bourquey certainly helped Chris open his heart up to our new addition, but Maxie was still a holdout. Two weeks into his adoption,

we took Bourquey to the groomer to get all of his stained, wiry hair shaved off. He was gone for almost two hours; Maxie visibly relaxed and warmed back up to us during that time. She was sitting contentedly on my lap when Chris came back from picking Bourquey up, and as soon as his happy little face came trotting into the house, Maxie launched herself off the couch, ran up to him, and started barking right in his face, as if to say, "WHAT ARE YOU DOING BACK HERE? DIDN'T YOU KNOW TO STAY AWAY?" She dropped back into her dour mood for a couple more weeks, while Chris and I continued to try to provide her with the support, stability, and reassurance we thought she needed.

Eventually, Bourquey's unstoppable loving started to chip away at Maxie's indifference. Chris and I would watch them on the doggy live stream at our day-care facility whenever Chris went out of town for work; they would stick close to each other, and one would continuously check in with the other throughout the day. Finally, though, they cemented their sibling bond at my parents' house when Chris and I went away for our first vacation since adopting Bourquey. They did absolutely everything together, and Maxie showed Bourquey all around this new and unfamiliar place. When we got back, we could feel the difference in their relationship.

Bourquey has gone through a great many changes since his adoption. When we adopted him, Bourquey was underweight and had cloudy eyes and a straggly, stained coat. We immediately started to feed him the same food

we'd been feeding Maxie for a couple of years. He has put on four needed pounds since his adoption, and over time the weight has nicely redistributed on his body. Thanks to the healthy, natural food and the grooming, Bourquey's coat grew in much fuller, beautifully white and wavy.

His emotional transformation has been even more astounding than the physical. On Bourquey's second day home, I reached out to pet him, and something about the direction, speed, or approach of my hand startled him. He shrank away from my reach. When he looked at me with fear in his eyes, I burst into tears. "Someone must have hit him," I sobbed to Chris. I slowly inched my hand toward his face in a clear, direct motion; Bourquey sniffed me, licked my hand, and I started to pet him gently as I cried.

The first six months home were also punctuated by Bourquey's terrible nightmares. He would bark and run and growl in his sleep, dreaming vivid dreams. Sometimes he would wake up snarling, snapping, and growling, as though reliving his worst memories. The only thing that seemed to help was a gentle hand on his back and speaking soft, comforting words to him. If startled awake, he would growl and look around with wild eyes until he realized that he was in his bed or on the couch or safe in the arms of one of us. I attributed these outbursts to some form of doggy PTSD. Unfortunately, Bourquey must have lived in a heightened state of alert on the streets. His acclimation to a secure, safe, and loving environment did not happen overnight, and even now we strive to reassure him of his safety (though, luckily, with much less frequency than a year ago). His bad dreams come days, sometimes weeks apart now. He rarely flinches away from a touch, even after experiencing the accidental smacks that happen between an uncoordinated owner and an enthusiastic dog.

The changes to Bourquey's appearance are astounding, but I continue to measure our progress by how he presents emotionally.

Not having raised Bourquey from a puppy, I didn't know what our relationship would be. After more than a year together now, I can say that Bourquey is the sweetest, most loving dog I have ever owned. He gives so much love to everyone he meets, even after the trials he has experienced. Our families—most of whom were skeptical about our adopting a stray senior dog—have fallen fully in love with him, and each person who meets him expresses their surprise at his having been a rescue dog. "You really lucked out with this one," they say. But I don't think Bourquey was the only beautiful, loving soul out in the shelters. Bourquey has definitely changed how we think about adding to our family. I don't know whether every dog in our future will be a senior dog adoption, but I can say with certainty that every dog from now on will be adopted.

CONNECT: 🔘 @PETEYTHEPOODLE

Rudy's Story
AS TOLD BY HIS HUMAN, KELLY

We adopted Rudy, a twelve-year-old puggle, at Christmas. We adopted him from someone we already knew who was simply tired of him and was considering having him put down. I had interacted with Rudy on numerous occasions and thought he was splendid.

I think the idea that kids need a puppy is silly. My kids didn't know the difference—Rudy was new to us and they were thrilled.

Owen, my three-year-old son, loved to hold Rudy's face close to his, kiss him, and tell him what a good boy he was. We were even able to socialize him quickly with our two house rabbits, which was an amazing bonus. For busy families with young children, a dog whose behavior and temperament are already known is invaluable. It made Rudy's transition into our family very smooth. He was immediately ours. Because he was a calm, mature, older dog, my kids were able to walk him easily, snuggle him excessively, and do the silly things kids love to do with dogs, like dressing him in a superhero cape.

Kids (and adults) may think they want a puppy, but often what they need is a mature dog. Rudy met all our needs!

SUSie tiP!

Exactly like it is with humans, it's the same for us canines when it comes to little kids: Some of us love 'em, some of us hate 'em, and some of us are somewhere in between. A dog who prefers adults over children is not unadoptable. This is a personality trait to be taken seriously, for the safety of both the dog and the little human, and requires responsible ownership and decision making by the adult human, as they are our providers and protectors. Of course many dogs adore young kids. But that doesn't make us doggies with a "leave me alone" attitude the abnormal ones. (Like me. I think kids are all right, but I prefer the company of predictable adults.) Another common misconception is that senior dogs cannot be adopted by families with young children. In a lot of cases, this couldn't be further from the truth! The important thing to keep in mind is that each dog has its own preferences and personality traits and deserves to be regarded on an individual basis.

Why Bo and Happy Are the Best Dogs

AS TOLD BY THEIR HUMAN BROTHERS, Elias and Luka

ELIAS (age fourteen):

Bo and Happy are the best things to talk to when you're upset, because, 1: They love you no matter what you do, and 2: They can't judge you for obvious reasons. Their never ending positive attitude also brings the mood in our home up substantially high. Thats why I love my two dogs so very much. My overall favorite thing to do with them is to simply just cuddle . . . a lot.

They can go right to sleep with you, because they won't pee on your bed. And not have your friends laugh at you during sleepovers because they think you peed yourself. You know what their personality is going to be like, for example if it's a cuddle bug or not.

LUKA (age eight):

Bo did normal dog things the first day at our house. Bo and Happy make my life better because when I cry they hang with me. I love taking Bo to the dog run. They always stampede into my legs, and Bo snorts a lot. (Best part of having two dogs at home.) People should always save dogs' lives. Because it makes you sad when thinking about all the dogs that die. But it makes me happy we saved our two dogs' lives.

King is a very special alumnus of Susie's Senior Dogs. He was a huge inspiration, and his story was loyally followed by many people. Everyone wanted to see King find his home, but it was proving to be a real challenge.

King

THE SUPERSTAR

On a visit to the New York City Animal Care Centers shelter in Brooklyn, I asked the shelter if I could meet with the oldest or "least adoptable" dog in their care. At around ten years of age, King was the oldest dog in the shelter, and because he was a pit bull, this was a double setback for him.

Shortly after meeting him, I posted King's story on the SSD social media pages. I explained that he was a friendly dog who had been found abandoned in an empty building in Brooklyn. We didn't know much about his history, but we knew King was a nice dog who needed a good home.

But nothing happened.

So I posted another update about this sweet, friendly dog just waiting to be adopted.

And still, no one wanted to claim him.

After several posts on SSD it was becoming clear that King was not going to be an easy case. He moved over to the Animal Haven shelter in SoHo, where he could be given unlimited time for his difficult search. After a few weeks we discovered that he suffered from a fear of abandonment and was also dealing with anxiety. At this point I knew King was going to have an especially hard time finding a home as the list of marks against him grew:

1. HE WAS OLD.
2. HE WAS A PIT BULL.
3. HE HAD ANXIETY.
4. HE WAS BEST LIVING WITHOUT OTHER PETS AT HOME.

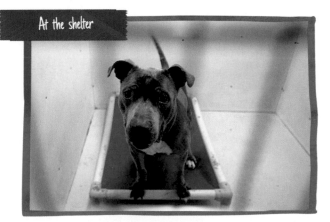

At the shelter

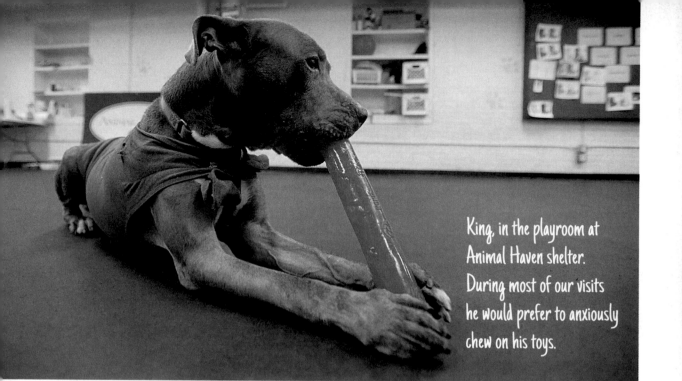

King, in the playroom at Animal Haven shelter. During most of our visits he would prefer to anxiously chew on his toys.

Over the course of the next seven months, King was posted more times on SSD than any other dog. By the time we got to King's tenth promotion, he had gained many encouraging and supportive fans from all over the world. Everyone was cheering him on to find his home! But still we could not find his special someone.

To make matters worse, the longer King spent at the shelter, the more withdrawn he was becoming. And his anxiety-related behaviors were becoming more pronounced. King was now less interested in human interaction and more focused on pacifying these anxious feelings by exerting all of his energy chewing toys. But I sensed this is not who King was underneath all of these behaviors.

And then one day everything changed. By this point King's story had been collectively shared more than 15,000 times—and one of those shares changed everything for King. A young woman reposted King's story on her personal Facebook page. Her cousin Lexa happened to see King's photo and fell in love with him. Lexa and her boyfriend, Tim, decided King would be the perfect dog for them. It was a true miracle!

As soon as King went home with his new parents, he lived like any king would. He ate at some of New York City's finest restaurants, he slept in bed with his mom and dad, he watched football on Sundays, and he even got to run free in the Michael Kors store when all the customers left and Mom closed up shop for the night. Because of Lexa and Tim, King gained the chance to live The Good Life.

Very sadly, less than four months later, King's new life was cut too short. He had shown no signs or symptoms, but a large tumor was suddenly detected in his lungs. He passed away at the animal hospital with his mom and dad by his side.

Many tears were shed for King. He had a family far larger than his two incredible parents, who had kept King's many fans updated on his Instagram account, @theking.of.newyork. But rather than focus on their loss, Lexa and Tim choose to focus on everything King did get to enjoy during his final months on earth. Because of them, he gained an entire life.

THE RAINBOW BRIDGE

The rainbow bridge began as a poem describing a beautiful meadow, where all our beloved pets arrive when they die. They know no pain or suffering or sadness, and when we join them in Heaven, they walk across a rainbow bridge to join us in eternity. Although not everyone is familiar with the poem, the idea of the rainbow bridge has become popular consolation for pet owners facing the most difficult of moments with a senior dog.

Time is irrelevant when it comes to love. Losing our beloved pets will always be difficult, and we'll always wish we had more time together. But we can find comfort in giving our senior pets the best possible end to their lives when that day comes. Whether it's days or months or years, we can choose to love them and care for them as they rightfully deserve.

When they cross to the other side, our pets are happy, healthy, and free. I am so thankful for all the humans who have given an older animal the opportunity to feel loved and a place to be comfortable before their time on earth was over and it was time for them to journey to the rainbow bridge.

After losing King, Lexa and Tim felt they needed some time to heal and would give it a few months before considering adoption again. But less than a month later, they adopted nine-year-old Diego from a city shelter in Los Angeles. Diego had been returned five times due to his separation anxiety and his need to be the only pet in the home. On his fifth return to the shelter, Diego was out of options. Because of Lexa and Tim's experience, they felt it was only fitting that they give Diego a chance.

In four days, Diego journeyed 3,000 miles across the United States with the help of six volunteer drivers. He arrived home without a hitch and immediately picked up where King left off. King will never be replaced, but he has paved the way for other special dogs to have a chance at experiencing The Good Life.

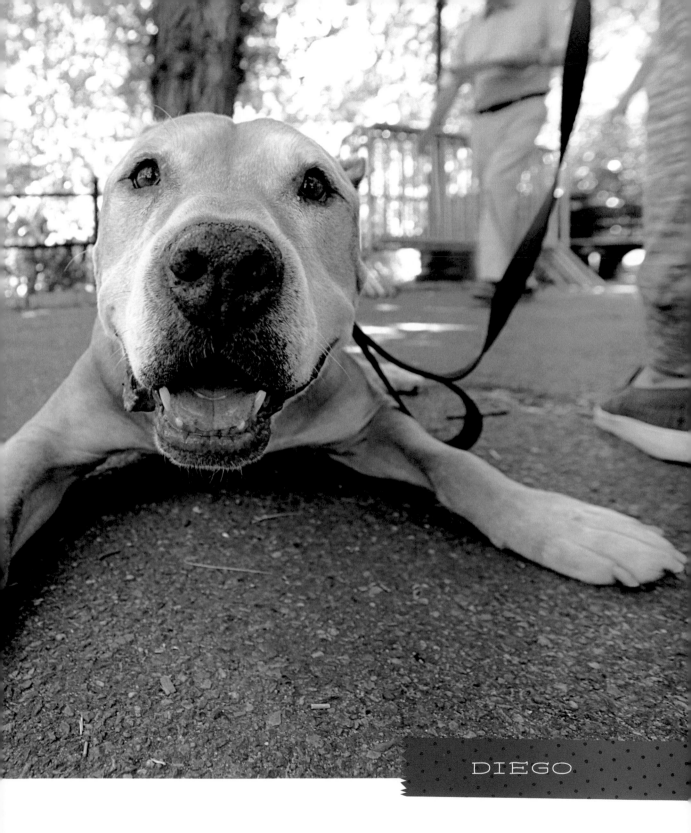

DIEGO

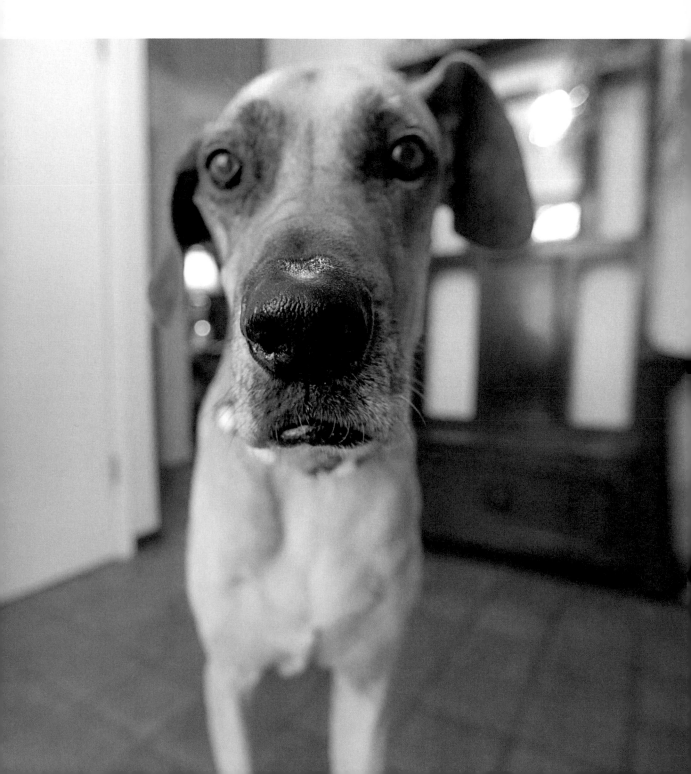

Zeke's Story As Told by His Human, Vicki

ZEKE

our years. That's how long the Great Dane tethered to a six-foot chain survived with no shelter and little food or water. Then a miracle occurred—rescue and, soon after, loving hearts took him into their forever home. Finally, life could really begin for the Great Dane known as Zeke. The tapeworm and pneumonia were banished and Zeke eventually gained sixty much-needed pounds.

Today a favorite hobby of Zeke's is chasing those pesky critters called squirrels. Zeke stalks his backyard, always on the lookout for an errant squirrel. In nine years, though, he's caught only two. Fortunately for the squirrels, Zeke enjoys the hunt but not the spoils, so he merely spits the squirrels out in a soggy ball, unharmed, to taunt him another day.

During his spare time, Zeke loves to stroll outside and bask in the sun, flat on his side with his legs sticking straight out . . . ahhhh. While sunning, Zeke often rolls around on his back, long legs flailing, because the soft grass feels oh so good. In fact, his fawn-colored coat often bleaches to white. Evidently it's true that blondes have more fun, from a Great Dane's perspective.

Zeke especially enjoys his home away from home, doggy day care. It's here that Zeke learned it was okay to bark and play with other dogs. He likes to jump on a table and play King of the Hill, easily nudging the other competitors off the edge until the Great Dane reigns supreme. After all, the word *great* is part of his identity!

When Zeke's family has to travel, he visits a doggy hotel where he has his own room and comfy bed. In the play area, Zeke is known as the enforcer. When other dogs' roughhousing gets chaotic, Zeke quietly eases himself between them, reminding the dogs to mind their manners and play nice! He also accompanies the caregivers during feeding rounds, acting as a greeter at each room, which tends to calm anxious dogs. All is well in the world if Zeke is there.

Daily activities also include delving deep into his toy basket and pulling out his cherished Lamby. Soft toys are always preferred, and a true gentleman, Zeke never, ever pulls the stuffing out of his toys. No, they are only gummed on—many of them lasting more than nine years, if they survive the washing machine.

Of course, talking a walk on his leash is a favorite adventure. Everyone in the neighborhood adores Zeke! Kids dash to the sidewalk to greet him, hang on his neck, and ruffle his fur . . . and Zeke loves them. At Halloween, children often greet him with shouts of "Marmaduke!" while parents busily snap his picture with their kids. Lucky is the child who gets a swipe of that Great Dane tongue, from chin to forehead.

Now, nine years after his rescue, Zeke's veterinarian refers to Zeke as the miracle dog. At thirteen years old, ancient in Great Dane years, Zeke is happy and healthy, albeit a little creaky. Truly a gentle giant, his golden brown eyes hold secrets of both good and bad days gone by. However, what Zeke's gaze really offers is unconditional love for anyone who takes the time to know him. All in all, life is good. Every day is a new adventure, and the Great Dane realizes that he is loved and, most important, protected. So Zeke quietly reigns over his snug world, content with the knowledge that he has truly found his forever home.

Susie's Senior Dogs Continues . . .

've been shocked at how quickly Susie's Senior Dogs has grown. In the very beginning, I thought it was going to be much harder to convince people what a gift old dogs are to us humans and how worthwhile adopting a senior dog can be. Adopting an older dog, which may be perceived as a disadvantage by some, can actually be viewed as a privilege. I have been awed by the number of people who have stepped up and committed to adopting dogs in this special age group.

I believe that the success of Susie's Senior Dogs can be mainly attributed to creating awareness. People have been rescuing senior dogs since long before SSD ever existed, but I have found that many animal lovers were simply unaware of the plight of senior dogs in shelters. A common phrase I hear is "I just didn't know!" Upon educating themselves about senior shelter dogs, and adoption in general, people find the decision to adopt a senior dog much more straightforward.

I am so thankful to all of the shelters, rescues, and foster homes who give value to senior dogs and put in their time and resources to care for them. And I am incredibly grateful for all the people who have opened their hearts to adopt a senior dog, giving them wonderful forever homes during their most precious years of life. (Although, as you've read throughout this book, most of us agree that the senior dogs actually give back to us so much more!)

The growing awareness of adoption and homeless senior dogs keeps me hopeful for the future of shelter dogs. I do believe that one day we will overcome the overpopulation problem and lower the high euthanasia rates in the United States. Significant change does not happen overnight, but along the way, every adoption is a big step in the right direction.

I hope these stories have inspired you to consider a senior dog the next time you're ready to welcome a pet into your life. Susie and Simon promise you won't regret it!

Good-bye, Susie

When I began working on this book two years ago, Susie was right by my side the entire time. I would often sit down to write with Susie on my lap and tell her, "Come on, Susie. Let's get to work!" Or I'd look at her and think: "What would Susie say?" She even came along to several meetings at the offices of Simon & Schuster in midtown Manhattan. My publisher says Susie was one of the easiest authors they've ever worked with! ☺

On April 22, 2016, our little Susie went to Heaven. As anyone who has lost a beloved pet understands, losing Susie was very hard for me. These little beating hearts bring so much love to our human lives, and their absence is heartbreaking.

But I have found comfort in continuing the work of Susie's Senior Dogs, in Susie's honor. All homeless senior dogs represent Susie to me because there is a big chance that any one of these stories could have been hers had she not crossed paths with Brandon. To imagine Susie as an unwanted senior dog in a shelter hurts me more than anything. And it's important to me to continue helping her senior dog friends who might not otherwise have a chance of finding forever love.

Susie always had a feisty, fighting spirit that kept chugging even as her little body slowed down. And that is my inspiration and my motivation: to keep chugging even when I don't feel like it. It's what Susie would do. ♥

Then Came Moby

We began fostering Moby on April 1, 2016. He was in horrific condition, both physically and emotionally, and he needed a comfortable place to stay while searching for his forever home. Moby had been surrendered over to rescue when his former owner fled the state; his condition indicated a very neglectful life in

Our first day

his previous home. He was said to be twelve years old.

Although adopting a new dog at that time wasn't something we had considered, Moby felt like a family member almost immediately. Of course we love all of our foster dogs, but Moby's presence in our home was different. Moby and Susie only spent three weeks together before our beloved Susie passed away, and their brief overlap of time together means so much to me. Moby was gradually regaining his strength while Susie was rapidly losing her health. It was a difficult and emotional time and we will be forever grateful that Moby found his way to us.

After Susie passed away, Simon and Moby helped to heal our hurting hearts. Simon doesn't have the same relationship with Moby as he did with Susie -- and that's perfectly normal and okay. Moby is very loving, adorably goofy, and incredibly easygoing (with occasional bouts of stubbornness!). He enjoys his nightly three-mile walks and he loves to explore the outdoors. Moby has gained some much needed weight and the vet estimates his true age to be around 8 years old. As it so often happens with newly adopted senior dogs, Moby has eased his way into our lives as if we've been together always. And we are so thankful to be able to call him ours. We love you, Mister Moby!

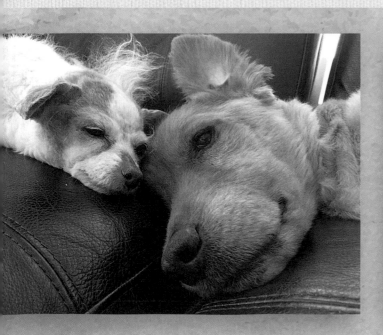

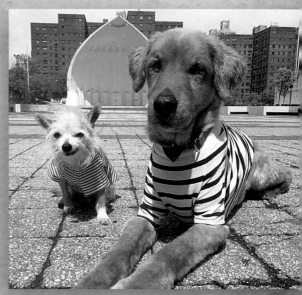

Acknowledgments

The Susie's Senior Dogs community is amazing and I am incredibly thankful to everyone who religiously follows along, positively comments on the social media posts, and helps to spread the good word for senior dogs. The individuals in the SSD community are largely responsible for assisting in so many adoptions. Thank you!

I am incredibly grateful to every person who has adopted a senior dog. This vulnerable, overlooked group of animals need more selfless people like you. The real work begins after bringing any pet home. While there is much reward, responsible pet ownership is a commitment to loving our rescued furry friends no matter what. And you are my heroes!

Writing this book has involved many more people than just me and Susie. It was originally suggested that this be a book about my own experiences and my senior dogs. But that didn't feel right—SSD is a collaboration of many people. Thank you to the amazing contributors who wrote the stories featured in this book from their heart.

Thank you to (in order of featured story): David Jahn, Kate Pickford, Angeline Sparks, Steve Greig, Carol Rothchild, Mary-Kay Lynde, Sophie Gamand, Jenny Mackay, Christine Raymond, Kelly Miller, Britany Spangler, Christine Vogel, Kelly Grgas-Wheeler, Helena Kohl, Robin Merrifield, Maggie Mazzarella, Jenny Hubbard, Cheryl West, Brit Dunlop, Catherine Langford, Dani Collins, Jenny Hughes, Dorie Herman, Suzie Smelyansky, Pamela Keld, Phyllis Rhodes, Melissa Evans, Christy Langston, Elias D'Onofrio, Luka D'Onofrio, and Vicki Dunlop.

Thank you to my agent, Brian DeFiore, for seeing the vision of Susie's Senior Dogs in book form. Thank you to the dog-loving staff at Gallery Books, who all teared up at our very first meeting. Thank you to Jennifer Bergstrom, Abby Zidle, and the entire team. A special thank-you to Jane Archer, the designer of this book, who saw it as her "heart project"!

My biggest thanks of all go to my love, Brandon, for always supporting me and my many ideas. Thank you for always being kind, gentle, and welcoming to all of the dogs who come through our door. Thank you for accepting my many tears (I cry a lot!) and listening to all of my doggy woes and happy tails. I love you so much!